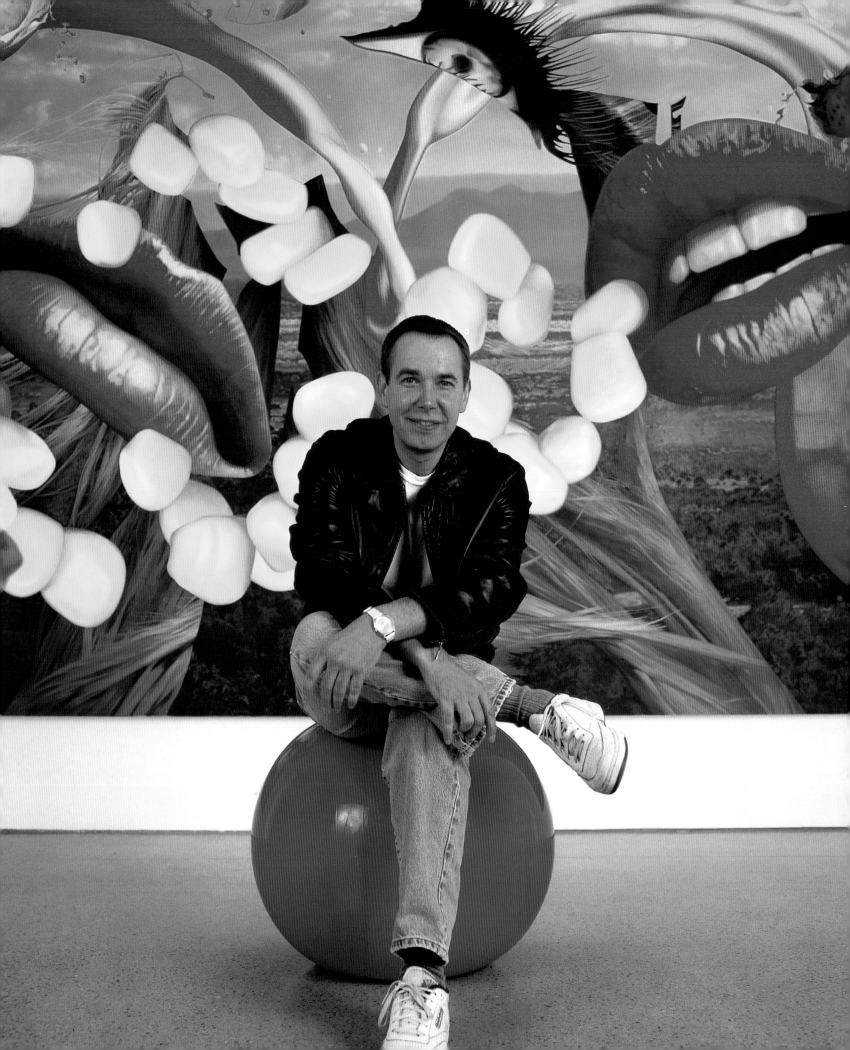

# JEFF KOONS

KUB
*Kunsthaus* Bregenz

**FÜR MICH IST KUNST KOMMUNIKATION.**

**Jeff Koons**

**Leihgeber der Ausstellung** *Lenders to the exhibition*

Anonym *Anonymous*

Anthony d'Offay Gallery, London

The Brant Foundation, Greenwich, Connecticut

The Broad Art Foundation, Santa Monica

Dimitris Daskalopoulos, Griechenland *Greece*

Stefan T. Edlis, Chicago

Gagosian Gallery, New York

Davide Halevim, Mailand *Milan*

The Dakis Joannou Collection Foundation, Athen *Athens*

Jeff Koons, New York

Angela und Massimo Lauro, Neapel *Naples*

No Limits Gallery, Mailand *Milan*, Neapel *Naples*

Norah und Norman Stone, San Francisco

Sammlung Scharpff in der *Scharpff Collection at* Hamburger Kunsthalle

Sonnabend Gallery, New York

Eckhard Schneider

## SURFACE AND REFLECTION

Kaum ein Künstler der mittleren Generation hat in den letzten zwanzig Jahren soviel Aufmerksamkeit und soviel Anteilnahme auf sich und sein Werk gezogen wie Jeff Koons. Von Anbeginn seiner Karriere haben die Medien und das Publikum jede Äußerung, jede Veränderung seines Werks, jede private Sensation hitzig diskutiert. Natürlich gehört diese Auseinandersetzung unverzichtbar zu seiner künstlerischen Strategie, denn kaum ein Künstler hat sich so der positiven Idee von Kunst als Kommunikation verschrieben wie Koons.

Seit seinem Eintritt in die Kunstwelt im Jahr 1979 sind die nacheinander entstandenen Werkgruppen *The Pre-New*, *The New*, *Equilibrium*, *Luxury and Degradation*, *Statuary*, *Banality* und *Made in Heaven* durchgehend von dieser grundlegenden Überzeugung geprägt gewesen. Hinzu kommt, dass kaum ein zeitgenössischer Künstler so fest wie Koons an die Macht der Oberflächen als Widerschein des Universellen und unserer Welt glaubt. Diese Begeisterung für das Reflexionsvermögen der Materialien, das Spiel des Lichtes, sind seit Anbeginn die Ingredienzien des verlockenden Trunks, aus dem sich die ästhetischen Sensationen des Werks von Koons zusammensetzen. Dennoch hat sich mit der Werkgruppe *Celebration*, an der er seit 1992 arbeitet, noch einmal eine Art Quantensprung vollzogen, sowohl was den Umfang als auch den handwerklichen und künstlerischen Anspruch dieser Serie betrifft. Im Endzustand soll sie aus zwanzig Skulpturen aus rostfreiem, hochglanzpoliertem Chromstahl und Polyäthylen bestehen sowie aus sechzehn großformatigen Gemälden. Die Gemälde verbreiten ihre celebratorische Aura mit Motiven wie einem Stück Geburtstagskuchen, einem Festhütchen, brillant funkelnden Satinbändern oder einem hängenden Herz mit Schleife.

Im November 1999 zeigte die Sonnabend Gallery in New York, noch in ihren alten Galerieräumen am West Broadway, die neue Werkserie *Easyfun*. Sie bestand damals noch aus elf Spiegeln und drei Bildern. Die Spiegel zeigen flache Formen von dreidimensionalen Tierfiguren – wie zum Beispiel Affe, Elefant, Bär, Känguru und andere. Jede Spiegelfigur besitzt eine andere Farbe, und ihre brillante Verarbeitung aus Kristallglas, Spiegelglas, farbiges Plastik und Edelstahl lässt sie merkwürdig artifiziell erscheinen, gleichzeitig aber strahlen sie den Optimismus und die beruhigende Einfachheit von Kinderspielzeug aus. Die mit ausgestellten Bilder *Cut-Out*, *Hair* und *Loopy* zeigen im Stil von Collagen montierte bunte Versatzstücke aus Reklame und Kinderwelt und verlockend gemalte Nahrungsmittel. Es sind Objekte und Bilder voller Optimismus und spielerischer Leichtigkeit in einer schwindelerregenden Balance zwischen Oberflächenreiz, Humor, Hintergründigkeit und der Reflexion der Realität. Die Begegnung mit dieser Serie war der Auslöser für diese Ausstellung im Kunsthaus Bregenz.

Nachdem seit langem in Ausstellungen keine Arbeiten von Koons zu sehen gewesen waren, verblüffte die Serie durch ihre objekthafte Reinheit und ästhetische Souveränität. Völlig überraschend hatte Koons seinem ästhetischen Universum ein neues Kapitel hinzugefügt. Dies schien alles das zu enthalten, was sich in zwanzig Jahren in barocken Spiralen entwickelt hatte: Die Vermählung Europas mit Amerika in der Kunst (und für eine kurze intensive Zeit auch im Leben). Koons selber sagt hierzu: „Ich verstehe mich als Schnittstelle zwischen der figurativen Tradition

Europas und dem amerikanischen Minimalismus."[1] Seit Anbeginn waren Koons' Werke von dieser Spannung geprägt, ohne dass es die Vorherrschaft des Einen über das Andere gegeben hätte. Die Hoover-Staubsauger in den neonbeleuchteten Glasschreinen (*The New*) und die in Wassertanks schwebenden Basketbälle (*Equilibrium*) waren, was ihre metaphorische und emotionale Aufladung betrifft, perfekte zeitgenössische Altäre amerikanischer Vorstadtkultur bzw. trophäenhafte Selbstportraits eines amerikanischen Jugendtraums. Im Kunstdiskurs erscheinen sie als Anverwandlung der Duchamp'schen Readymades mit ihrer Botschaft von der neuen emanzipierten Rolle des Betrachters nunmehr in Gestalt der kühlen Objekte des Minimalismus. Das alles war gepaart mit der berechnenden Strategie des Konzeptualismus und dem positiven Präsentationspragmatismus der Popkultur. Mit diesen Werken definierte Koons auf einen Schlag sein konzeptuelles Bild vom Künstler und seine Mission – so wie es Jasper Johns mit seinen Flaggenbildern getan hatte.

Mit *Luxury and Degradation*, *Statuary* und *Banality* wird die Nähe zu europäischen Vorbildern endgültig und handgreiflich spürbar. Die Statuierung komerzieller Ikonen zu blitzblanken Kunstobjekten verläuft nun auf dem schmalen Grad zwischen Banalität und artifizieller Zuspitzung. Die skulpturale Aura dieser Werke erinnert an die Unberührtheit polierter Sakralität der Skulpturen von Brancusi. Und bei *Banality* und *Made in Heaven* bedient sich Koons nicht nur europäischer Handwerkertradition, er entdeckt dabei auch für sich das Barocke als Mittel zur Modellierung von Mysterien und zur Manipulation von Materialien. Koons benutzt diese Ideen der Vermischung von Kunst und Leben so, dass durch Unschuld, Schönheit, Sicherheit und Vertrauen alles Vulgäre, Pornografische und Materielle transformiert wird. Gleichzeitig erweitert er den Gedanken des Readymade, indem er zusammen mit Cicciolina selbst zu einem menschlichen Readymade wird.

Die eingangs erwähnte Zäsur, die die Serie *Celebration* markiert, beruht nicht allein auf ihrer schieren Größe und Unermesslichkeit. Die Werke beschwören vielmehr eine positive Grundhaltung, die dem unbegrenzten Vertrauen des Kindes gegenüber der Welt ähnelt. Wie in der Welt des Kindes geht es hier nicht um Erkenntnis, sondern es geht um Vertrauen. Und so lautet die Maxime von *Celebration* nicht „Erkenne Dich selbst", sondern „Sieh Dich selbst", wie Keith Seward in seinem Aufsatz *Frankenstein im Paradies* schreibt.[2] Die Spiegel gehen in dieser Grundhaltung noch einen Schritt weiter. Mit ihren scharfen, als Tierformen wiedererkennbaren Umrissen trennen sie sich klar als Form und als Objekt von der Umgebung. Ihre Botschaft ist deutlich, ihr Versprechen unbegrenzt. Ich bin das, was meine Form vorgibt und ich bin mehr: Licht und Farbe und spiegelnde Oberfläche, und ich biete jeder neuen Umgebung und jedem neuen Individuum seine spezielle reflektierte Realität an. Anders jedoch als andere Werke der Kunst halten sie den Betrachter durch den Reflex des jeweils Aktuellen stets im Gegenwärtigen seiner Zeit und seines Seins.

Die Serie *Easyfun – Ethereal* ist die neueste Serie von Jeff Koons. Diese aus Computerphantasien entstandenen Bildschöpfungen erinnern an die makellose Präzision eines Roy Lichtenstein oder James Rosenquist, ebenso wie an die surrealen Phantasien eines René Magritte oder eines Salvador Dali. Bei diesen Bildern hat Koons jede persönliche Handschrift getilgt, so dass diese lediglich auf der konzeptuellen Ebene existiert. Ausgangspunkt der Arbeiten sind kunstvolle Collagen von Bildern aus Reisebroschüren und Modemagazinen, von Bildern der naiven Ess- und Spielfreuden von Kindern und der sinnlich betörenden Attraktionen von Erwachsenen.

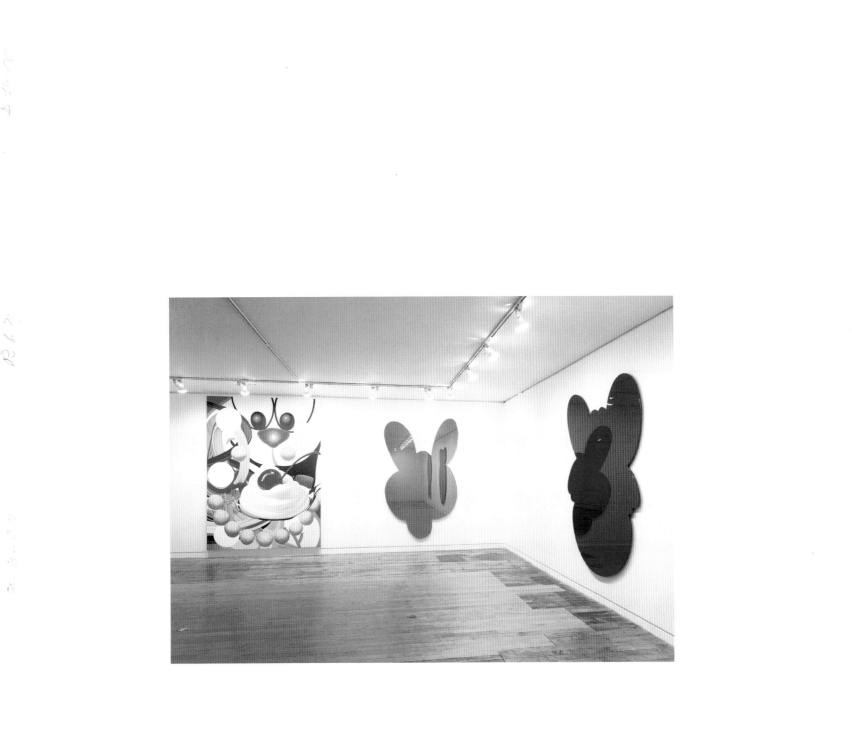

Ausstellung *Exhibition* **Easyfun**
Sonnabend Gallery, New York, 1999

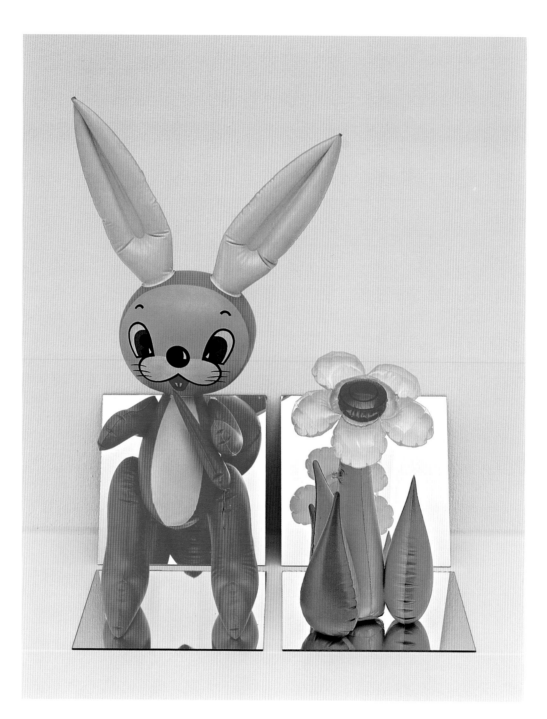

**Inflatable Flower and Bunny** 1979, aus der Serie **The Pre-New**

Das Kunsthaus Bregenz zeigt mit über zwanzig großformatigen Werken aus den Jahren 1995-2001 die umfangreichste Ausstellung von Jeff Koons seit den Retrospektiven von 1992/93 in den USA und in Europa. Die drei gezeigten Werkgruppen *Celebration, Easyfun, Easyfun – Ethereal* fokussieren die zentralen Ideen der künstlerischen Arbeit von Jeff Koons. Die Auswahl der Werke stellt daher keine Retrospektive dar, sondern bietet einen „Künstlerblick" auf die Idee der Verknüpfung von Oberfläche und Tiefe, von Malerei und Objekt, von Tradition und Moderne. In der Gegenüberstellung des Kinderblicks in den *Celebration-* und *Easyfun-*Serien mit dem Erwachsenenblick in den neuen Gemälden präsentiert diese Auswahl somit die Brillanz der Werke von Jeff Koons in ihrer Brechung und Vermischung von europäischer und amerikanischer Tradition.

Ein Ausstellungsprojekt dieses Kalibers wäre ohne die großzügige und tatkräftige Unterstützung vieler nicht denkbar gewesen. Zu allererst möchte ich Ileana Sonnabend und Antonio Homem, den Direktoren der Sonnabend Gallery, New York, und Jason Ysenburg, dem stellvertretenden Leiter der Sonnabend Gallery, danken. Sie, ebenso wie Max Hetzler, haben das Ausstellungsprojekt von Anfang an tatkräftig unterstützt und immer wieder durch wertvolle Ratschläge und Vermittlungen zu Leihgebern gefördert. Gleiches gilt auch für Anthony d'Offay von der Anthony d'Offay Gallery, London, und Marie Louise Laband, seiner Geschäftsführerin, die zudem durch ihr Entgegenkommen den jetzigen Ausstellungszeitpunkt für das Kunsthaus Bregenz erst ermöglichten. Großzügige Unterstützung erfuhren wir auch von der Gagosian Gallery, New York. Hier möchte ich besonders dem Direktor, Larry Gagosian, sowie der Ausstellungsdirektorin Stefania Bortolami und ihrer Assistentin Stephanie Maria Dieckvoss danken. Durch ihre Vermittlung zu zahlreichen Leihgebern kam maßgeblich das dritte Kapitel der Ausstellung *Easyfun – Ethereal* zustande. Speziell danken möchte ich Massimo Lauro, dem Direktor der No Limits Gallery, Mailand und Neapel, für seine bewundernswerte Bereitschaft, unsere Ausstellung entscheidend zu unterstützen. Für die Vermittlung eines Schlüsselwerks aus der *Celebration* Serie möchte ich mich bei Katerina Gregos, der Kuratorin der Dakis Joannou Stiftung in Athen bedanken.

Ganz besonders dankbar bin ich den Leihgebern der Ausstellung, darin eingeschlossen der Künstler. Ihre überaus großzügige Bereitschaft sich für die Sommermonate von bedeutenden und zum Teil fragilen Werken zu trennen, ließ die Ausstellung in diesem Umfang und mit dieser künstlerischen Qualität erst Wirklichkeit werden. Ich danke der Autorin des Textbeitrags, Alison Gingeras. Ermöglicht wird dieses große und in der jungen Ausstellungsgeschichte des Kunsthauses wichtige Projekt unter anderem durch die Unterstützung der Hypo Landesbank, genannt sei hier ihr Direktor Jodok Simma, und der Axa Nordstern Colonia Versicherungs-AG, Generaldirektor David Furtwängler. Danken möchte ich dem gesamten Team meines Hauses für seinen unermüdlichen Einsatz, um aus der Idee zu dieser Ausstellung Wirklichkeit werden zu lassen, besonders meinen Assistenten in diesem Projekt, Herbert Abrell und Cornelia Marlovits.

Mein herzlicher Dank aber geht an Jeff Koons und seinen Assistenten Gary McGraw. Das Vertrauen und die Unterstützung des Künstlers machten letztlich die Präsentation einer Ausstellung möglich, die – wie wir hoffen – einen wichtigen Beitrag zur vertieften Rezeption eines künstlerischen Werks ermöglicht, das in der zeitgenössischen Kunst seinesgleichen sucht.

[1] *Spiegel Kultur Extra*, Nr. 4, 1998, S. 11
[2] Seward, Keith: Frankenstein im Paradies, in: *Parkett* 50/51, 1997, S. 81

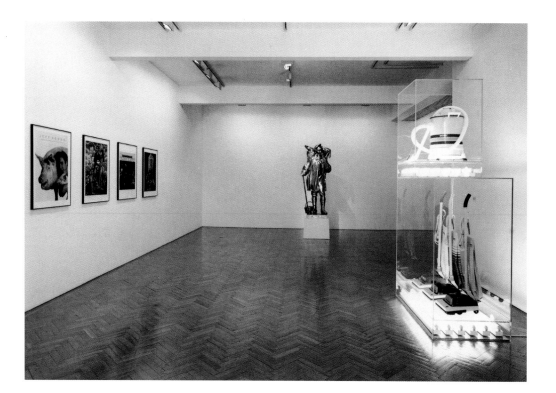

Ausstellung *Exhibition* **Jeff Koons: A Survey 1981-1994**

Anthony d'Offay Gallery, London, 1994

**Eckhard Schneider**

## SURFACE AND REFLECTION

In the past twenty years, hardly an artist representing the middle generation has received as much attention and interest in both his person and his work as Jeff Koons. From the beginning of his career, media and audiences alike have engaged in heated debates over his every comment, over each new turn his work took, each sensation in his private life. Of course, this public discussion is also an indispensable part of his artistic strategy, for again there is hardly an artist who has committed himself so wholly to the positive idea of art as communication as Koons.

Since he first appeared in the art world in 1979, his successive series of works *The Pre-New*, *The New*, *Equilibrium*, *Luxury and Degradation*, *Statuary*, *Banality* and *Made in Heaven* have all been influenced by this fundamental conviction. Furthermore, hardly another contemporary artist believes so strongly in the power of the surfaces as a reflection of the universal and of our world. This enthusiasm for the reflective power of materials and the play of light have from the very beginning been the ingredients in the seductive potion which makes up the aesthetic sensations of Koons's work. Nevertheless, the series *Celebration*, which he has been working on since 1992, represents yet another quantum leap, not only in respect to range but to the craftsmanship and artistic demands of this series as well. Upon completion, the project is to comprise twenty sculptures of high-gloss, polished, chrome stainless steel and polyethylene as well as sixteen large-scale paintings. The paintings will express their celebratory aura with motifs like a slice of birthday cake, a party hat, brilliantly glittering satin ribbons, or a heart dangling from a bow.

In November 1999, the Sonnabend Gallery in New York, with its galleries still at their old location on West Broadway, showed Koons's new series of work *Easyfun*. At the time, it consisted of eleven mirrors and three paintings. The mirrors showed flat forms of three-dimensional animal figures – for example, monkey, elephant, bear, kangaroo, and others. Each mirror figure is a different color, and their brilliant construction of crystal, mirror, colored plastic, and stainless steel make them appear strangely artificial while they, at the same time, emanate optimism and the calming simplicity of children's toys. The paintings also being shown here, *Cut-Out*, *Hair*, and *Loopy*, show a collage-style assemblage of colorful elements taken from ads and the world of children and tantalizingly painted foods, like a cherry, whipped cream, milk and Cheerios. They are objects and images full of optimism and playful lightness in a vertiginous balance between superficial appeal, humor, profundity, and the reflection of reality. Experiencing this series was what triggered the current exhibition at Kunsthaus Bregenz.

After a period of quite some time where none of Koons's works had appeared in exhibitions, this series surprised and amazed viewers with its object-like purity and aesthetic elegance. Koons had suddenly added a new chapter to his aesthetic universe. It seemed to contain everything that had developed over the past twenty years in baroque spirals: the marriage of Europe and America in art (and for one short intense moment, in life as well), as Koons commented: "I see art as the interface between the European figurative tradition and American Minimalism." From the very beginning, Koons's works were marked by these two poles, however without either one asserting dominance over the other. The Hoover vacuum cleaners in their neon-lit glass shrines

(*The New*) and the basketballs suspended in their water tanks (*Equilibrium*) were, as far as their metaphoric and emotional content was concerned, perfect contemporary altars of American suburban culture, or trophy-like self-portraits of an American childhood dream. In terms of art discourse they seemed to embrace the Duchampian readymades with their message of the new emancipated role of the viewer in the shape of the cool objects of Minimalism. All this was coupled with the calculating strategy of Conceptualism and the positive presentation pragmatism of pop culture. With these works, Koons defined in one fell sweep his conceptual view of the artist and his mission – the way Jasper Johns had done with his flag paintings.

In *Luxury and Degradation*, *Statuary*, and *Banality*, the proximity to European models becomes definitively and palpably obvious. Making commercial icons into sleek clean objects of art now takes place along the thin line between banality and artificial hyperbole. The polished sculptural aura of these works is reminiscent of the chaste, polished, sacral nature of Brancusi's sculptures. Moreover, in *Banality* and *Made in Heaven* Koons is not merely making use of the European craftsman's tradition, he also discovers baroque for himself as a means of modeling mysteries and of manipulating materials. Koons uses these ideas of mixing art and life for his artistic purposes, transforming in this way through innocence, beauty, security, and trust the visible elements of the vulgar, pornographic, and material that are omnipresent in his work. At the same time, he expands the concept of the readymade by becoming together with Cicciolina – in much the same way as Gilbert and George – himself a human readymade.

The aforementioned departure that is punctuated by the series *Celebration* does not rely alone on its size and sheer immeasurability. But instead, the works conjure up a positive fundamental view not unlike the boundless trust with which a child looks at the world. As in the world of a child, we are not concerned here with knowledge and insight, but with trust.

„The maxim of Celebration is not to know, but to see thyself," as Keith Seward writes in his essay „Frankenstein in Paradise"[2]. In this fundamental view the mirrors go yet a step further. With their sharp contours of the recognizable shapes of animals, they distinguish themselves clearly as forms and as objects from their surroundings. Their message is unmistakable, their promise boundless. I am what my form dictates and I am more: light and color and reflecting surface, and I offer to each new surrounding and each new individual its own reflected reality. Unlike other works of art they, through the reflex of each moment, keep the viewer constantly in the present of his time and being.

*Easyfun – Ethereal* is Jeff Koons's most recent series of works. These paintings created from computer fantasies remind us of both the perfect precision of a Roy Lichtenstein or James Rosenquist and the surreal fantasies of a René Magritte or Salvador Dali. In these paintings Koons has eradicated every personal signature, so that they only exist on a conceptual level. The point of departure of the works are elaborate collages of images assembled from travel brochures and fashion magazines, from images of the naive food- and play-pleasures of children and the sensuously beguiling attractions of grownups.

With more than twenty large-scale works from 1995-2001, Kunsthaus Bregenz presents the most comprehensive exhibition by Jeff Koons since the retrospectives of 1992/93 in the USA and·Europe. The three series on display, *Celebration*, *Easyfun*, *Easyfun – Ethereal*, are the focus

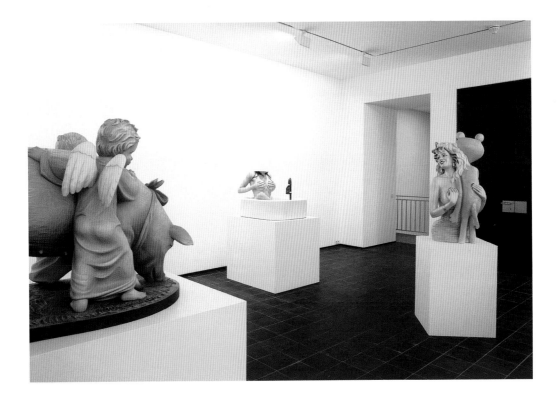

Ausstellung *Exhibition* **Banality**

Galerie Max Hetzler, Köln, 1988

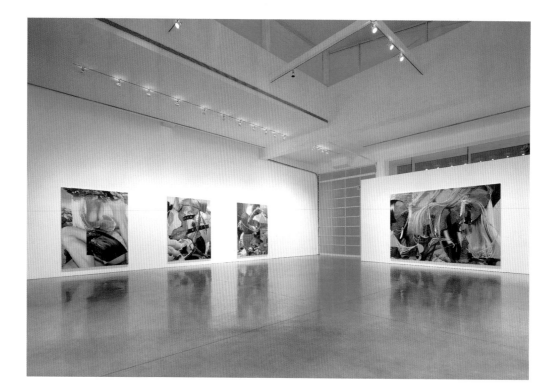

Ausstellung *Exhibition* **New Paintings**

Gagosian Gallery, Los Angeles, 2001

of the central ideas of Jeff Koons's artistic work. This selection of works, therefore, cannot be considered a retrospective but offers instead an "artist's view" of the idea of linking surface and depth, painting and object, the traditional and the modern. By juxtaposing the view of the child in the *Celebration* and *Easyfun* series with the view of the adult in the new paintings this selection presents the brilliance of Jeff Koons's works in their departure from and mixing of European and American traditions.

An exhibition project of this caliber would be unthinkable without the generous and strong support of many institutions and individuals. Above all I would like to thank Ileana Sonnabend and Antonio Homem, the directors of the Sonnabend Gallery, New York, as well as the assistant director of the Sonnabend Gallery Jason Ysenburg. They, along with Max Hetzler, actively supported this exhibition project from the very beginning and provided us with numerous valuable suggestions and contacts to loan institutions. The same goes for Anthony d'Offay of the Anthony d'Offay Gallery, London, and Marie Louise Laband, his manager, without whose cooperation the current exhibition dates at Kunsthaus Bregenz would not have been possible. Moreover, we also received generous support from the Gagosian Gallery, New York. I would like to take this opportunity to express my special gratitude to the director Larry Gagosian, as well as the exhibition director Stefania Bortolami and her assistant Stephanie Maria Dieckvoss. It was through their contacts to numerous loan institutions that *Easyfun – Ethereal*, the third part of this exhibition, could be added to this project. I am especially grateful to Massimo Lauro, the director of the No Limits Gallery, Milan and Naples, for his admirable willingness to give such strong support to our exhibition and passing on to us the key works from the *Easyfun* series. Let me also thank Katerina Gregos, the curator of the Dakis Joannou Foundation in Athens for supplying one of the key works in the *Celebration* series.

A very special thanks to all those who have lent us works for the exhibition, including the artist himself. Without their generous willingness to part with important and in some cases fragile works during the summer months, an exhibition of such dimensions and artistic quality would not have been possible. The special mention at the beginning of this catalogue of all those who have lent us works is my way of expressing my deep respect for each and every one of you. Furthermore I would like to thank the author of this catalogue, Alison Gingeras. This great project, which is so important in the short exhibition history of this institution, was also made possible by the support of Hypo Landesbank, in the name of its director Jodok Simma, and of Axa Nordstern Colonia Versicherungs-AG, in the name of its general manager David Furtwängler. I would also like to thank the entire team at Kunsthaus Bregenz for its tireless work in turning this idea into reality, above all my assistants in this project, Herbert Abrell and Cornelia Marlovits.

Finally, I would like to thank Jeff Koons and his assistant Gary McGraw. The faith and support of the artist have made this exhibition possible, and we hope it will help to deepen the understanding and reception of a body of artistic work that in the world of contemporary art is certainly in a class of its own.

---

[1] *Spiegel Kultur Extra*, No. 4 (1998), p. 11. (English translation of original German quote).
[2] Seward, Keith: Frankenstein in Paradise, in: *Parkett*, no. 50/51 (1997), p. 71.

# Celebration

CELEBRATION HANDELT VON HOFFNUNG,

VON DER ZUKUNFT UND DEM RESPEKT

VOR DER MENSCHLICHKEIT.

Jeff Koons

Hanging Heart  1995-98

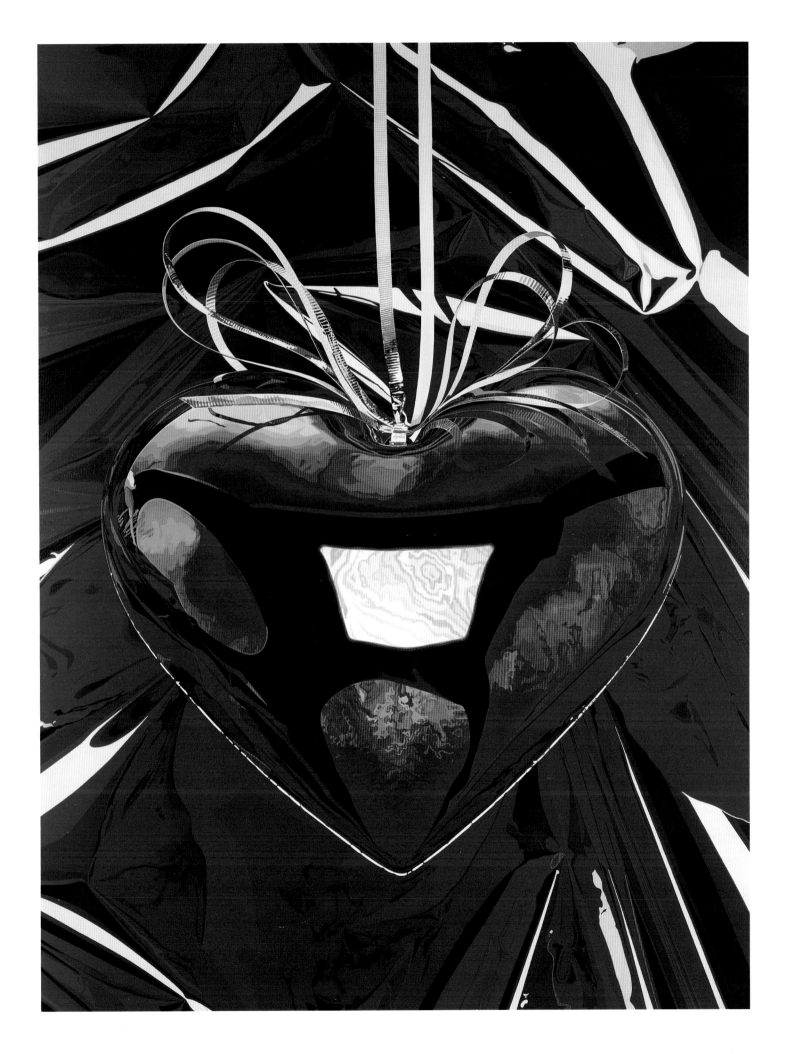

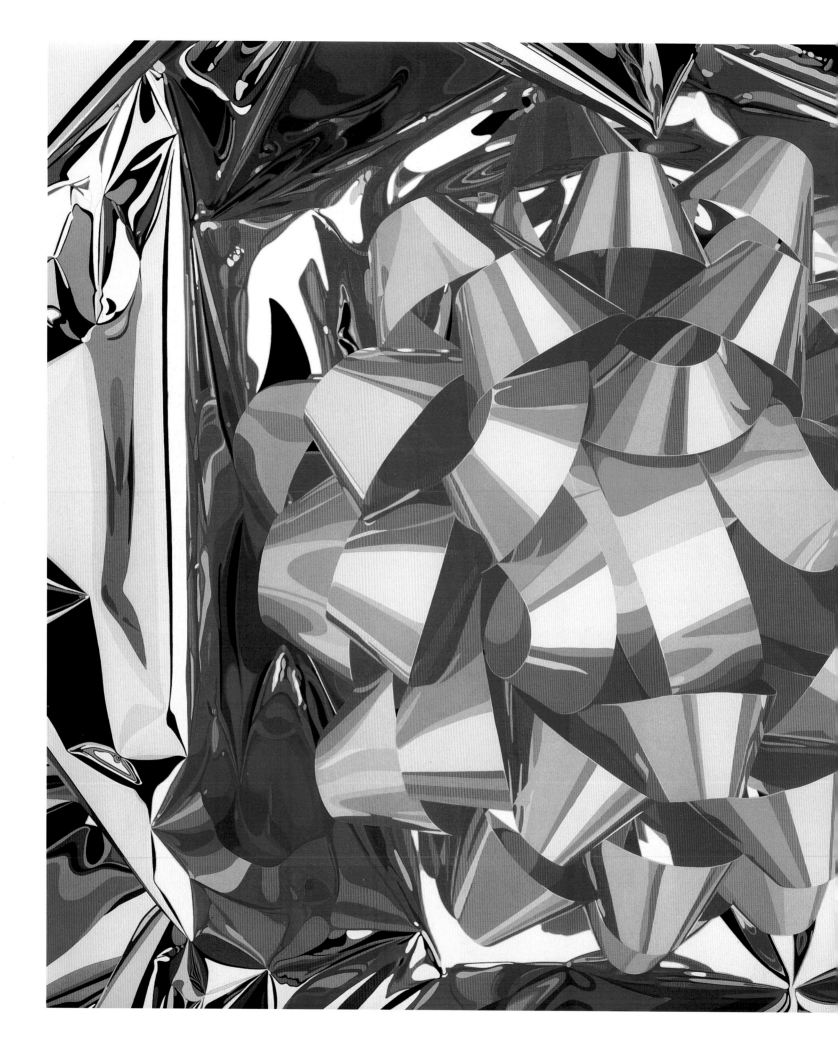

Pink Bow  1995-97

**Bread with Egg  1995-97**

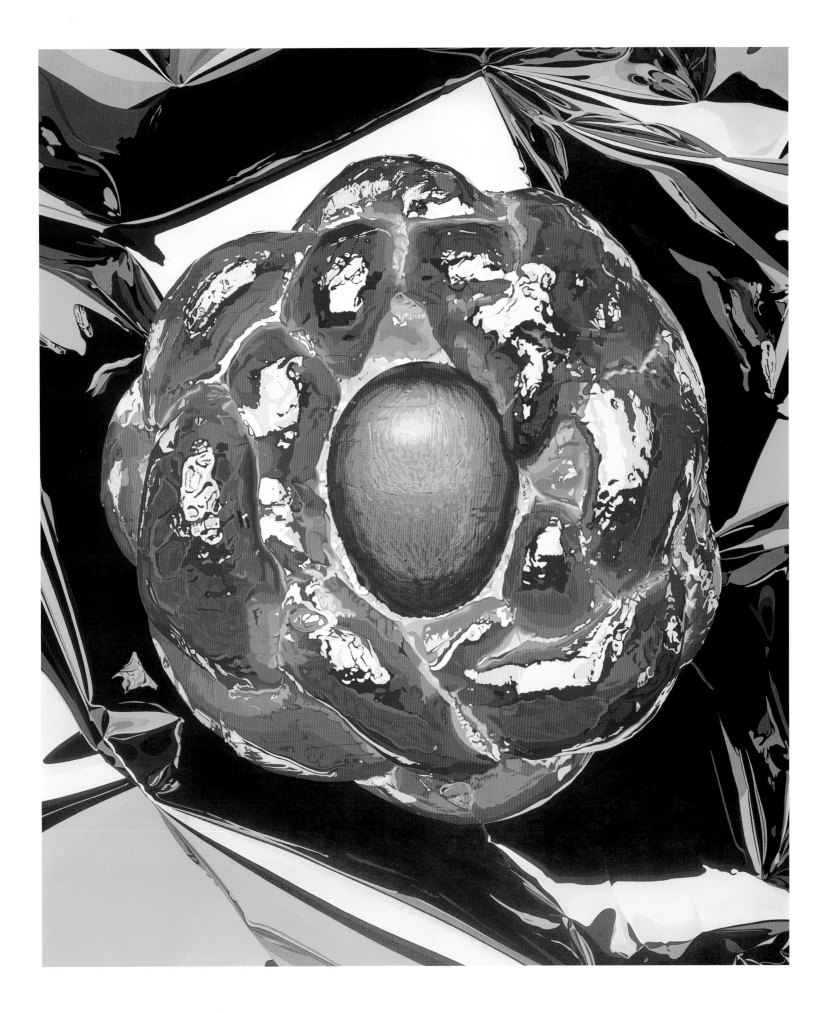

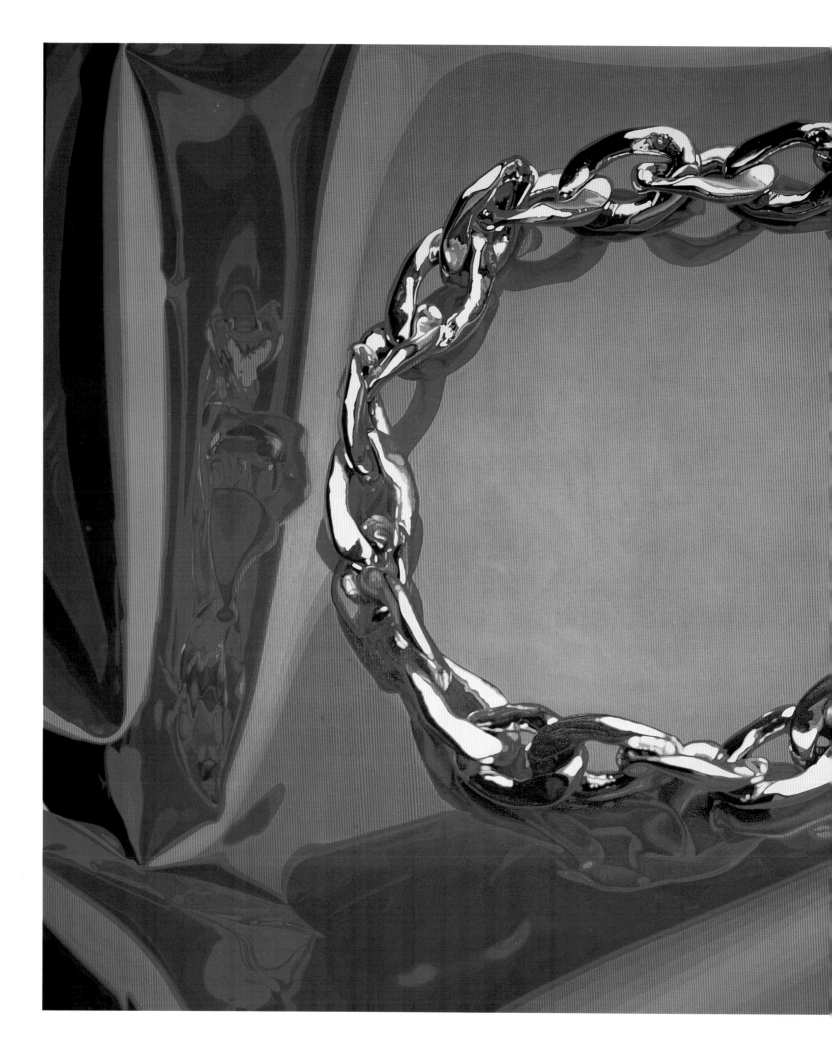

Bracelet 1995-98

DIE BILDER HABEN ETWAS VON

EINEM MALBUCH AN SICH,

EINE ART SIMPLIZISTISCHE QUALITÄT.

SIE SIND BUNT UND SEHR POP.

SIE HABEN EINE UNSCHULDIGE AURA.

Jeff Koons

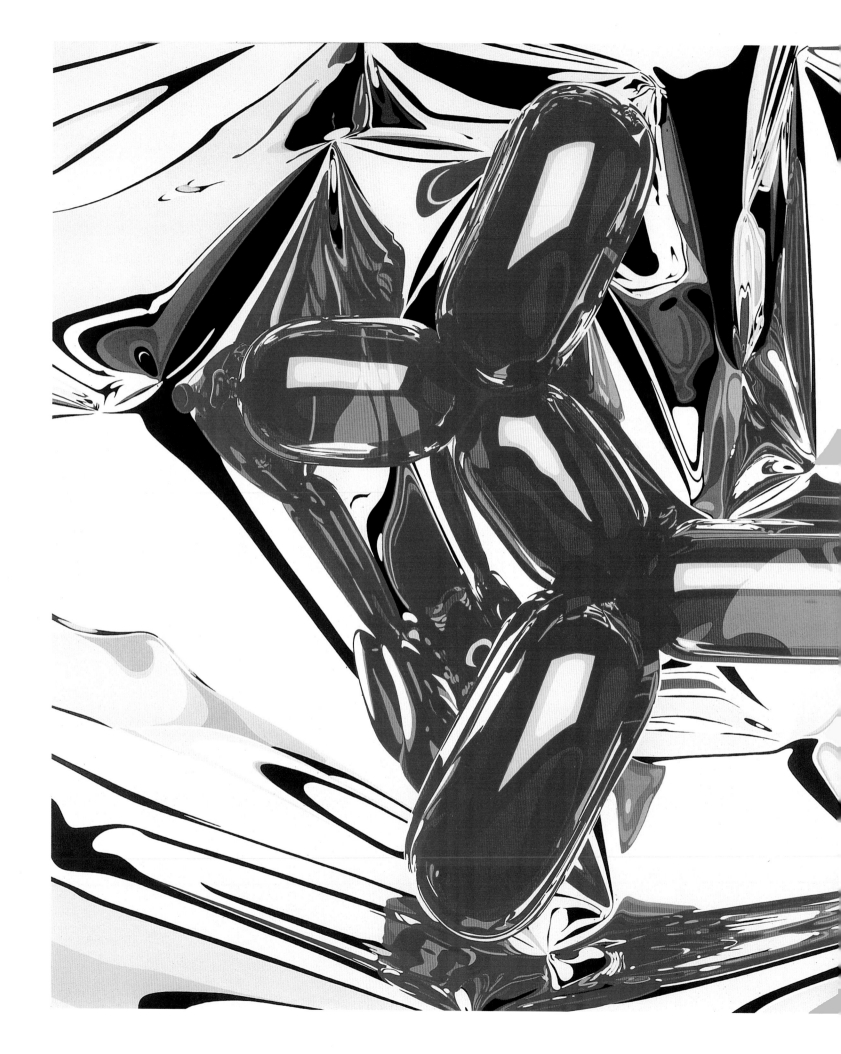

Balloon Dog 1995-98

Alison Gingeras

## DAS COMEBACK DER ERNSTHAFTIGKEIT: JEFF KOONS 1995-2001

### Die Anatomie eines Comebacks

Ein meteoritenhafter Aufstieg, ein unvermeidlicher Fall in Ungnade, eine schwierige Phase der Sühne, eine glanzvolle Wiederauferstehung. Der immer größere Ausmaße annehmende Kult um Berühmtheiten macht die Comeback-Story zu einem der beliebtesten Genres in den USA. Von der populärsten Show des Kabelfernsehens, VH1's rührselige Dokumentationen über fast vergessene Popstars, *Behind the Music*, bis hin zu dem in der New York Times kürzlich groß aufgemachten Artikel über die in der Kunstszene von Downtown Manhattan erfolgte (Wieder)Aufnahme von Rob Pruitt – eines „Bad Boy"-Künstlers, dem man in den frühen neunziger Jahren politische „Incorrectness" in Rassenfragen vorgeworfen hatte, was seinen völligen Abgang von der Kunstwelt für mehr als sieben Jahre zur Folge hatte – das alles belegt, dass eine überzeugende Comeback-Geschichte zwei entscheidende Komponenten hat.

Die erste und wichtigste ist, dass die meisten Comebacks von den ständig sich wandelnden Modeströmungen abhängig sind. Die zyklische Wiederkehr einmal vergessener oder aus der Mode gekommener Trends in der populären Kultur kann eine einzelne Karriere oder einen offiziell für tot erklärten Stil oder eine Kategorie vollständig rehabilitieren. Der Rückbezug heutiger Modedesigner auf die beiden extremen Pole der achtziger Jahre – die neureiche, exzessive Zurschaustellung des Glamourösen, wie sie in der Fernsehserie *Dynasty* exemplarisch vorgeführt wurde (Steven Meisels Kampagne für Versace), und auf der anderen Seite der gammelige Straßenlook (Anne Demulsteers elegante Neuauflage des Post-Punk) – ging Hand in Hand mit der Rückkehr von New Wave und Post-Punk-Musik aus derselben Zeit. Die gegenwärtige Faszination und nostalgische Begeisterung für Duran Duran oder Depeche Mode auf MTV findet ihr Echo in der Kunstwelt in Ausstellungen wie PS1's 1984 oder auch in Hollywoods Leinwandadaption von Bret Easton Ellis' achtziger Jahre-Roman *American Psycho* – und dies alles ist Teil eines umfassenderen Prozesses der Rückgewinnung kulturellen Territoriums.

Die zweite wesentliche Komponente einer erfolgreichen Comeback-Geschichte ist eine ernsthafte und länger während Reue seitens des gefallenen Stars. Im Fall von Rob Pruitt hatte die vernichtende Kritik seiner Ausstellung mit dem Titel *Red, Black, Green, Red, White and Blue* (Leo Castelli Gallery, 1992) das völlige Aus seiner Karriere zur Folge. Zu einem Zeitpunkt, als die Kunstwelt des „Neo Geo" überdrüssig zu werden begann, warf man Pruitt und seinem damaligen Mitarbeiter Jack Early reinen Zynismus vor, und was noch viel schlimmer war, man bezeichnete sie als Rassisten. Wie Pruitt jedoch in dem begeisterten Artikel der New York Times über sein kürzliches Comeback einräumt, ist seine Wiederaufnahme in die Kunstwelt wesentlich von seinem Eingeständnis abhängig, dass die kontroverse Castelli-Ausstellung als Provokation gemeint war, jedoch zum falschen Zeitpunkt stattgefunden hat. „Wir wollten auf die Vereinnahmung von schwarzen Helden durch die überwiegend im Besitz von Weißen befindlichen Firmen hinweisen, aber es war uns nicht klar, welche Landmine wir da gelegt hatten", sagte Pruitt. „Zu dem Zeitpunkt war die Kunstwelt äußerst empfindlich gegenüber Identitätsfragen und politischer

Korrektheit, aber du konntest nur dann als Autorität auftreten, wenn du darüber sprachst, wer du warst und woher du kamst." Nach diesem öffentlichen Eingeständnis seiner Reue hat Pruitt geschickt „bescheidene Demut" bekundet, und außerdem hat er „einen humorvollen Zug und das Praktische einer Martha Stewart in das traditionell strenge Genre der Konzeptkunst" eingeführt, um sich wieder in die Herzen des New Yorker Kunstpublikums einzuschmeicheln.[1]

Abgesehen davon, dass Pruitts Geschichte eine gut geeignete Illustration zur Anatomie des Comebacks ist, stellt sie ein interessantes Gegenstück zu den Aufs und Abs der letzten Jahre in der Rezeption eines anderen Künstlers dar, der auch als „Bad Boy" gilt, nämlich Jeff Koons. Nach seiner berühmtesten Werkgruppe *Made in Heaven* (1989-92) und der Enthüllung seiner monumentalen Pflanzenskulptur *Puppy* außerhalb von Kassel im Jahr 1992 hat Koons sich sieben Jahre lang aus der Öffentlichkeit zurückgezogen. Trotz der Kontroverse, die durch den „pornografischen" Inhalt von *Made in Heaven* ins Rollen gebracht worden war, lag der Grund für Koons' fast völliges Verschwinden nicht in moralischer Entrüstung. Es war auch nicht durch eine starke Veränderung in der Mode oder im Geschmack ausgelöst worden – denn auch wenn Koons eng mit einer Künstlergeneration der 1980er Jahre in Verbindung gebracht wird (Bickerton, Halley, Salle, Steinbach etc.), geht seine Bedeutung doch weit über diesen heute karikierten Moment der Kunstproduktion hinaus. Gerade das vergangene Jahrzehnt hat Koons in seiner Geltung bestätigt. Finanziell betrachtet hat der astronomische Marktwert von Koons' „klassischen" Werken[2] sämtliche Auktionsrekorde gebrochen, während viele seiner Zeitgenossen in Vergessenheit geraten sind. Etliche etablierte Künstler von Paul McCarthy über Charles Ray bis zu Dan Graham haben eindeutig die zentrale Bedeutung von Koons' Werk für ihre eigene, scheinbar so unterschiedliche Arbeit betont. Einige gingen sogar so weit, ihn direkt zu „kopieren".[3] Da er sich also keine Sünde in der Kunstwelt hat zu Schulden kommen lassen und auch keine Wendung gegen die Moden in der Kunst vollzogen hat, warum ist Jeff Koons dann zeitweise aus unserem Blickfeld verschwunden? Woran liegt es, dass die Arbeiten, die die Jahre 1995 bis heute umfassen und die in der Ausstellung im Kunsthaus Bregenz zu sehen sind, als Teil seiner eigenen Comeback-Geschichte verstanden werden könnten?

### Die *Celebration*-Saga

Viele Journalisten haben mit Genuss von dem dramatischen Verlauf der Ereignisse berichtet, die sich in Koons' Leben seit der Geburt seines Sohnes Ludwig Koons abgespielt haben. Dazu gehörte auch das Ende seiner höchst publikumswirksamen Ehe mit Ilona Staller und ihre unerfreuliche Auseinandersetzung um das Sorgerecht für das Kind.[4] Während diese Ereignisse nicht mit einer sorgfältigen Betrachtung seines Werkes verschmolzen werden sollten, waren aber die Jahre, die schließlich zu der Serie *Celebration* geführt haben, ein entscheidender Wendepunkt für Koons sowohl in seiner Kunst als auch in seinem Leben.

1994 begann Koons mit einem ehrgeizigen Projekt von sechzehn fotorealistischen Gemälden und zwanzig Skulpturen aus rostfreiem Stahl, alle von monumentaler Größe und fröhlich-überschwänglich in ihrer Geisteshaltung. Sie alle befassen sich mit jenen Symbolen und Objekten, die mit der Ausübung von Ritualen des Alltagslebens zu tun haben – mit Geburtstagen, Feiertagen

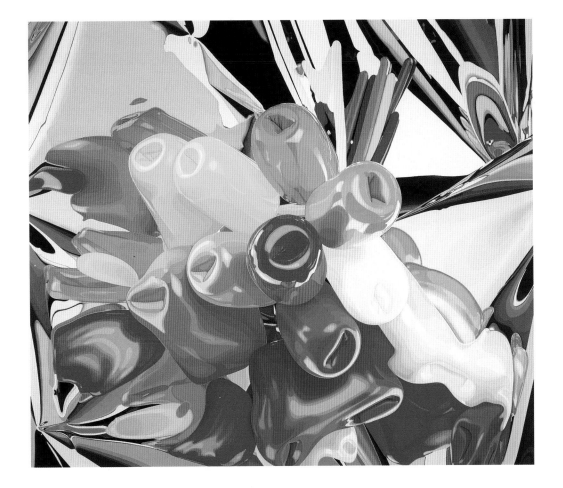

**Tulips** **1995-98**, aus der Serie **Celebration**

und anderen festlichen Gelegenheiten. *Celebration* führt Koons' Beschäftigung mit den Objekten und Erfahrungen der Kindheit in früheren Werken weiter und beinhaltet auch den Wunsch, wie er selbst gesagt hat, „mit meinem Sohn zu kommunizieren (...) um ihm zu sagen, dass ich die ganze Zeit an ihn gedacht habe".[5] Jede einzelne Arbeit, ob Gemälde oder großformatige Skulptur, isoliert eine Auswahl von Partyabfall und nimmt diesen in barocker Detailfreude unter die Lupe. Da gibt es einen prallen roten Ballonhund, eine phallische Ballonblume, einen Strauß anthropomorpher Ballontulpen, einen wunderbar typischen Geburtstagshut, einen Tellersatz aus rotem und gelbem Plastik, ein Stück rosa-weißer, klebrig-süßer Torte, ein gewöhnliches silbernes Armband, ein zerbrochenes Osterei, eine ganze Ansammlung von Spielzeugfiguren, eine glänzende rosa Schleife, einen Haufen Play-Doh-Knetmasse, ein monumentales Stück Popcorn.

Von 1994 bis 1996 lief in Koons' Atelier eine ganze Armee von Assistenten herum (zu einem bestimmten Zeitpunkt waren es bis zu siebzig Assistenten[5]), die alle daran mitwirkten, sein bis dahin arbeitsintensivstes und kostspieligstes Projekt zu Ende zu führen. Trotz dieser höchst unüblichen Mobilmachung von qualifizierten Arbeitskräften, die an die Zeiten von Renaissance-Werkstätten zurückdenken lässt, kam der Termin für die Enthüllung von *Celebration* im Guggenheim Museum Soho im Jahr 1996 näher und verstrich ungenutzt.[6] Das Maß an Perfektion, das Koons für die Herstellung dieser gigantischen Skulpturen aus hochglanzpoliertem Stahl verlangte (ganz zu Schweigen von den Jahren, die es benötigte, um die Gemälde herzustellen, die erst kürzlich fertig geworden sind), führte dazu, dass der gesamte Werkkomplex fast drei Jahre (von 1996-99) in seinem Atelier ungenutzt liegen blieb. Tatsächlich ist *Celebration* bis heute noch nie vollständig ausgestellt worden und die Mehrzahl der Skulpturen befindet sich noch immer in der Herstellung (nur eine Auflage von *Moon*, *Balloon Dog* und *Balloon Flower* ist bisher nach Koons' genauen Angaben fertiggestellt worden). Trotz dieser schwierigen Bedingungen sind die Werke nicht in Vergessenheit geraten. Etliche Modelle seiner Skulpturen und Gemälde wurden an prominenter Stelle in den Zeitschriften *Artforum* und *Parkett* abgebildet, was dazu beitrug, Koons' Besessenheit, nahezu unmögliche Herstellungsstandards zu erreichen, berühmt und berüchtigt machte, und außerdem gab seine Abwesenheit vom Ausstellungszirkus in den Jahren 1992 bis 1999 Futter für seine Comeback-Geschichte.

Wenn Koons über die sagenhafte Finanzierung seiner Werke spricht, weil er keinerlei Abstriche an die Herstellungsqualität der Gemälde und Skulpturen machen wollte, kommt er regelmäßig auf einen häufig missverstandenen Begriff in seiner Arbeit zurück: die Frage des Vertrauens. „Wenn ich ein Kunstwerk mache, versuche ich Handwerklichkeit in einer Weise einzusetzen, dass der Betrachter hoffentlich ein Gefühl von Vertrauen bekommt. Ich möchte auf keinen Fall, dass jemand ein Gemälde oder eine Skulptur anschaut und in irgendeiner Weise das Vertrauen verliert."[7] Dass Koons dies keineswegs ironisch gemeint hat, beweisen all die Jahre seiner obsessiven Überwachung (ganz zu Schweigen von der finanziellen Belastung), die er bei der genauen Einhaltung der detaillierten Produktionsbedingungen für die *Celebration* Serie walten ließ. Um dieses Vertrauen zu rechtfertigen und zu kultivieren, muss das Objekt selbst nach formaler und konzeptueller Perfektion streben, egal wie schwierig dies physisch oder finanziell zu verwirklichen ist. Die beeinträchtigende Wirkung auf Koons' Karriere gegen Ende der 1990er Jahre ist ein Plädoyer für seine Glaubwürdigkeit. Während viele schnell bei der Hand waren, die *Celebration*

Saga als den Augenblick von Koons' „Absturz" zu interpretieren, hat sie ganz im Gegenteil als ideales Beispiel dafür gedient, die häufigen Zynismus-Beschuldigungen wie auch die formalistischen Abwertungen der 1980er Jahre in ein neues Licht zu rücken. Die neuesten „Abstürze" werden mit Schwäche begründet, aber auch mit moralischem Versagen, mit der Aufgabe von Werten oder Idealen – doch all das war bei Koons nicht der Fall. Seine extreme Ernsthaftigkeit, seine Unfähigkeit, das „Vertauensgefühl", das er in seinem Werk nährt, aufzugeben, all das hat ihn in diese lang während und unbequeme Situation gebracht, die seine zeitweise Abwesenheit von der Kunstszene verursachte. Kann man Koons nach einer solchen Geschichte immer noch als einen kaltblütigen Zyniker bezeichnen? Als einen postmodernen Hochstapler? Oder ist nicht vielmehr **Ernsthaftigkeit** das Schlüsselwort für seine Comeback-Geschichte?

### *Easyfun*: Zurück in der Szene

Im Herbst 1999 kehrte Koons in die öffentliche Arena mit einem Werkkomplex zurück, den er zum ersten Mal in der Sonnabend Gallery in New York ausstellte und dem er den Titel *Easyfun* gegeben hatte. Dieser für Koons so typische Neologismus ist, wie die meisten seiner Unternehmungen, enttäuschend einfach. Was soll „Easyfun" überhaupt bedeuten? Eine Tautologie? Kann Spaß überhaupt hart sein? Das Werk gibt keine unmittelbare Antwort zur Erklärung des Titels: Fünfzehn neue, wandmontierte Skulpturen aus hochglanzpoliertem Edelstahl säumten die Wände der Sonnabend Gallery, und jede hatte in etwa die Umrisse und die Form eines gigantischen, comichaften Tierkopfes. Ein hellgrüner Affe (*Monkey*), ein rot gefärbtes Walross (*Walrus*), ein rosafarbenes Känguru (*Kangaroo*), ein hellgelbes Pony (*Pony*), ein silberstahlfarbener Esel (*Donkey*) – Koons sagt uns damit, dass dieser zoomorphe Tierpark aus glänzenden Flächen „dazu beitragen soll, dass ihr euch wohl fühlt".

Während die Skulpturen in Bezug auf das „reale" Motiv, das der Betrachter bei diesem neuen Werkkomplex vor sich hat, keine großen Geheimnisse verraten, gibt die vielschichtige Ikonografie in den drei *Easyfun*-Gemälden in der Sonnabend Gallery – *Loopy*, *Hair* und *Cut-Out* (alle Arbeiten von 1999) – einen Ansatzpunkt für die rätselhafte Seite von Koons' Comeback. Alle Gemälde aus der neuen Serie (einschließlich derjenigen, die er nach der ersten Ausstellung gemacht hat), sind in Stil und Kompositionsweise gleich: eine Collage aus scheinbar unvereinbaren Motiven, die von fotorealistischer Perfektion sind. Diese Arbeiten sind nach einer ähnlichen Methode gemacht wie die *Celebration*-Leinwände. Koons hat sich dabei einer Technik bedient, die man als Serienmalerei bezeichnen könnte. Die ursprünglichen Abbildungen werden zunächst auf die Bildoberfläche projiziert, um die generellen Formen und Umrisse des Bildes mit Bleistift festzuhalten, und dann wird jeder Quadratmillimeter der Bildfläche mit der Hand bemalt, um die genauen Farbtöne, Formen und Texturen zu erhalten, wie sie auf dem Originalfoto, das als Vorlage dient, zu sehen sind. Während sich bei den meisten Objekten der *Celebration* Serie die ganze optische Sorgfalt auf ein einzelnes Objekt richtet (*Cake*, *Broken Egg*, *Bracelet* – Torte, zerbrochenes Ei, Armband), bestehen die *Easyfun*-Gemälde aus einer Kakophonie kommerzieller Abbildungen, die aus billigen Reklamebildern stammen. Diese Abbildungen lassen sich in zwei Kategorien unterteilen: die unschuldigen, konsumierbaren Genüsse der Kindheit (Fastfood, Hinterhofspiele,

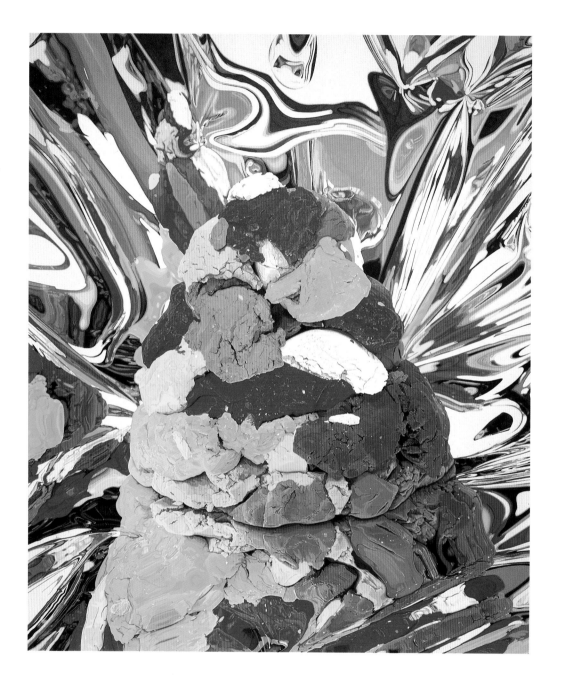

**Play-Doh** 1995-2000, aus der Serie **Celebration**

Vergnügungspark-Ausflüge) und die lustvollen Vergnügungen der Erwachsenenwelt (auffällige Spitzenhöschen und BHs, glänzende Lippen und Fingernägel, perfekt gebräunte Beine).

Was für die meisten Leute nichts weiter als optische Umweltverschmutzung ist, füllt Jeff Koons' umfangreiches Archiv mit Ausschnitten aus Zeitschriften und Zeitungen, die nahtlos zu Kollagen aneinander geklebt werden, um auf jeder Leinwand einen dicht beschichteten Bildraum zu erzeugen. Stilistisch wirken diese Arbeiten wie eine perfekte Kristallisation der amerikanischen neo-avantgardistischen Malerei seit 1960. Das Erbe von Popart ist in *Easyfun* nur allzu offensichtlich: Ihre unverfälschten Oberflächen erinnern an den Perfektionismus eines Roy Lichtenstein, während ihr offensichtlichster Bezug eindeutig zu James Rosenquist geht, dessen ausgiebige Beschäftigung mit dem Vokabular der Werbung und der Technik der Schildermalerei für Koons, wie er selbst zugab, den entscheidenden Bezug für diese Arbeiten darstellte.[8] Doch auch Koons' Zeitgenossen und seine Malerkollegen, die es in den achtziger Jahren zu Starruhm gebracht hatten, müssen als wichtige Bezugsquelle bei seinem Durchstöbern der visuellen Hoch- und Alltagskultur genannt werden. Wie Robert Rosenblum in seinem Aufsatz über *Easyfun* so richtig bemerkt hat, gibt es einen entscheidenden Unterschied zwischen Koons und seinen Vorläufern, und der liegt in seiner Wiederbelebung „der Sprache der höchst wirkungsvoll ausgeschmückten Werke des deutschen Barock und Rokoko, eines Stils, den er humorvoll aber nutzbringend als ‚Barokoko'[9] bezeichnet hat."

Anders als bei Salle und Rosenquist sind Koons' Gemälde frei von linguistischen Spielereien, Wortspielen und politischem Kommentar oder psychologischer Befrachtung. Ihre Kraft kommt gerade von dem, was Koons von solchen Vorbildern zu subtrahieren in der Lage ist – seine Arbeiten sind ohne alle Umschweife flach. Als Kontrapunkt zu der räumlichen Komplexität und Detailverliebtheit des Barokoko sind die Motive dieser Gemälde vollständig „leer". Die Anwesenheit von Menschen in den *Easyfun*-Gemälden ist auf Fragmente beschränkt; niemals ist ein Motiv „vollständig" zu sehen. Wenn der menschliche Körper evoziert wird, so geschieht dies durch körperlose Gliedmaßen oder die leere Hülle von Bekleidungsstücken. *Pam* (2001) zeigt beispielsweise die sinnliche Stelle eines gebeugten Frauenknies und ein beschnittenes Segment vom Brustansatz, während *Auto* (2001) zwei Paar geöffnete Lippen vorführt, die mit Gloss geschminkt sind, und den Schritt einer Frau in blauer Bikinihose mit einem gepierceten Nabel darüber. In *Blue Poles* (2000), einem Gemälde aus der *Easyfun – Ethereal* Serie, sind die Gesichter von Kindern in Tier/Außerirdischen Halloween-Kostümen durch ein riesiges Stück Frühstücksflocken ersetzt. Trotz der sich wiederholenden bildlichen Evokation einer schrecklichen Fragmentierung des Körpers ist die Gesamtstimmung von *Easyfun* auf herausfordernde Weise optimistisch zu nennen, und zwar nicht nur in ihren wogenden Formen und fröhlichen Wirbeln, sondern auch in ihren sinnlichen Exzessen. Mit ihrer Übernahme der „barocken Ekstase"[10] sind Koons' neue Gemälde weit mehr als ein simpler Kommentar zur Entfremdung des menschlichen Subjekts in unserer heutigen Konsumgesellschaft. Ihn darauf zu reduzieren, hieße, ihn zu kurz zu interpretieren.

Was ist es, über die Wiederbelebung des Barokoko-Geistes und die augenfällige Abwesenheit eines vollständigen Motivs hinaus, das in der *Easyfun* Serie angesprochen wird? *Cut-Out*, das erste Gemälde aus dieser Serie, könnte den Schlüssel dazu liefern. Es ist vielleicht das „mini-

malistischste" von Koons' jüngeren Werken und zeigt den Kopf eines Arbeitspferdes, der in einer kitschigen, comichaften Weise dargestellt ist. Wie der Titel besagt, ist das Gesicht des Pferdes herausgeschnitten, sodass man sein eigenes Gesicht in das Oval legen kann, um sich so fotografieren zu lassen – solche zweidimensionalen Figuren findet man häufig in Vergnügungsparks und auf Jahrmärkten. Eine Hand voll durch die Luft wirbelnder Cheerios-Frühstücksflocken (von der Packung kopiert) und ein Schuss Milch ersetzen das Gesicht des Kindes, das sich sonst in dem Ausschnitt gezeigt hätte. Im oberen Bereich der Komposition sieht man anstelle des Himmels ein fragmentiertes Bild von Mount Rushmore. Jede Bilderschicht bedient sich eines leicht unterschiedlichen Stils von Realismus und eines unerschiedlichen Illustrationsstils, wodurch ein Gefühl von Dissonanz sowohl in der Form wie auch im Motiv verstärkt wird. Als Koons einmal am Rande über *Cut-Out* und seine Beziehung zur „Identität" sprach, meinte er: „Meine Arbeit handelt mehr vom Betrachter als von irgendetwas sonst. Meine Arbeit schafft ein Hilfssystem, damit Leute mit sich selbst zufrieden sind und Selbstvertrauen haben (…) Mount Rushmore im Hintergrund von *Cut-Out*, das soll soviel sagen wie ‚Wenn du einmal groß bist, kannst du Präsident zu werden…', und die herumfliegenden Frühstücksflocken mit der Milch dahinter: das ist eben Optimismus."[11] Solche Kommentare könnten zu schnell als lakonische Provokation oder ironische Antwort auf den amerikanischen Traum abgetan werden – die klassische vom Tellerwäscher zum Millionär-Geschichte, jeder kann einmal Präsident werden, Identität ist nur ein leeres Gefäß.

Denkt man über die Aussage von *Cut-Out* bezüglich Identität nach und fragt nach deren Verhältnis zu den zweidimensionalen Spiegelskulpturen in *Easyfun*, könnte es einem eher weiterhelfen, Koons beim Wort zu nehmen. Im Laufe der Rezeption der ersten *Easyfun*-Ausstellung bei Sonnabend waren etliche Kritiker schnell bei der Hand, eine psychoanalytische Lesart auf die Tierspiegel zu projizieren. Viele von ihnen stürzten sich sogleich auf die lacanianische Metapher des Spiegelstadiums und seine Beziehung zu Koons' offenbar leerer Subjektivität. Mit einer solchen Lesart wird das Werk sicherlich überschätzt – was könnte harmloser sein als ein Haufen glänzender Spiegelflächen? Die Antwort lautet sowohl „Ja" wie „Nein". Es ist nicht das erste Mal, dass Koons strategisch den Naiven spielt. Indem Koons die angeblich regressiven Objekte und Bilder der Kindheit untergräbt (*Easyfuns* allzu vereinfachte Tiersilhouetten, die klebrig-süßen Esswaren, die regressive Heterosexualität), verweigert er systematisch jede soziologische, psychologische oder anders geartete kritische Lesart seines Werkes – sei es in Begriffen, die seiner eigenen Absicht entsprechen, oder als „gültige" Interpretation. Auch wenn er unverblümt mit solchen möglichen Assoziationen flirtet, ist seine Motivwahl niemals naiv, lediglich transparent.

Wenn der Betrachter *Bear* oder *Donkey* anschaut, ist er zuerst und vor allem mit seinem eigenen Ebenbild im Spiegel konfrontiert. Das Werk selbst gibt nichts preis. Wie Koons sagt, „es geht darum, ein Werk zu schaffen, das den Leuten hilft, sich von Urteilen frei zu machen."[12] Anstatt eine gültige Bedeutung oder ein feststehendes Urteil zu schaffen, versucht Koons ernsthaft, die traditionellen humanistischen Erwartungen, die in die Kunst gesetzt werden, klein zu machen. Man könnte sein Werk als **Undurchsichtigkeitsmaschine** verstehen, es werden dabei transparente oder lesbare Assoziationen Schicht um Schicht übereinander gelegt, bis die Schicht so dick ist, dass keine Interpretation mehr daran haften bleibt. (Die Schichten türmen sich nur auf: Ja, wenn du groß bist, kannst du Präsident werden! Ja, diese Spiegel handeln von dem Prozess der Subjekt-

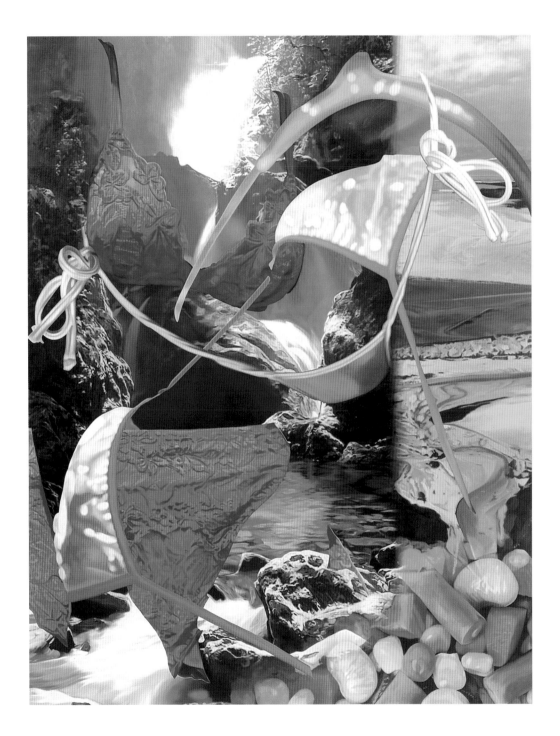

Desert 2001, aus der Serie **Easyfun – Ethereal**

bildung! Ja, diese Gemälde handeln von der Konsumgesellschaft!) Jede definitive oder festgelegte Erklärung (soziologisch oder politisch) gleitet ab, weil Koons' Gemälde und Skulpturen keinen ideologischen Zugriff gestatten. *Easyfun* ist offen und gleichzeitig leer (von Pathos und kritischer Aussage gereinigt) und ist insofern ein undurchdringliches Objekt, das dazu dient, die gesellschaftliche Erwartung an die Kunst zu entlarven. Unsere Erwartung an eine zugrunde liegende „Bedeutung" seines Werkes bleibt undurchsichtig, also unerfüllt – Koons setzt schlau eine Kettenreaktion aus Frustrationen in Gang. Humanistische Erwartungen an Seele, Authentizität und andere kritische Botschaften werden negiert. Die produzierte Undurchsichtigkeit ist ein Rauchschleier, der unsere Aufmerksamkeit von der Bedeutung des Objekts auf die Werte und Widersprüche des Systems, in dem es produziert wurde, umlenkt.

Die Wirksamkeit dieser Undurchsichtigkeitsmaschine wird klar, wenn man die ersten Besprechungen von *Easyfun* in den Zeitungen liest. Christian Viveros-Fauné schreibt in der *New York Press*: „Koons Werke verhalten sich wie leere Gefäße, die jede unschuldige Beobachtung in sich aufnehmen, jeden Tropfen Legitimität, der von einem weißen Kubus erhältlich ist, aufsaugen, und sie schrubben die dekadente, geldbesessene Museumskultur sauber, die unbedingt die Farce aufführen will, die seine Kunstproduktion darstellt."[13]

Während solche Anschuldigungen für Jeff Koons nichts Neues sind, beweist diese Kritik, dass er immer noch in der Lage ist, den Kritiker zu einem reaktiven Rückzug in die Mythen der Hochmoderne zu treiben. Viveros-Fauné (und zumindest die Hälfte derjenigen, die bei der Vernissage in der Sonnabend Gallery anwesend waren) beklagt den Verlust von „Unschuld" und „Legitimität" und den „Verfall" des Kunstkapitals. Sind es nicht scheinheilige Notrufe – wer kann wirklich von sich behaupten, von der Jagd nach Kapital (als Geld, als geistiger Besitz oder sonst wie) unbefleckt zu sein? Wer glaubt wirklich an diese Art von Legitimität? Welche Wertvorstellungen liegen diesen Vorwürfen zugrunde? Und diese scheinheiligen Notrufe zeigen in aller Schärfe den Widerspruch zwischen den „hohen" Erwartungen an die Wirkungen der Kunst und den „schmutzigen" Machtbeziehungen, die für das Überleben der Kunstwelt notwendig sind.

Vielleicht ist die Falle, die Koons den Kritikern stellt, wirkungsvoller als solche selbsternannten politischen Künstler, wie Hans Haacke, die sich bestimmter Reportagetechniken bedienen, um die zweifelhaften Geschäftsverbindungen von Treuhändern des Museum of Modern Art oder eines Moguls der Kunstwelt wie Peter Ludwig zu demaskieren. Wenn Koons auch in seiner subversiven Ernsthaftigkeit kontingent ist, so kann er in seinem Beharren auf „Vertrauen" doch als ein politischer Künstler angesehen werden.

Eines ist sicher, *Easyfun* beschließt das Kapitel von Koons' Rückkehr in die Welt der Gegenwartskunst. Ernsthaftigkeit – Rauchschleier, nicht Zynismus – ist seine Lösung, um Affekte hervorzurufen, aber auch, um seiner Comeback-Geschichte eine neue Wendung zu geben.

Alison M. Gingeras ist Kuratorin für Gegenwartskunst am Musée national d'art moderne, Centre Pompidou, Paris.

[1] Mia Fineman, „Back in The Arms Of The Art World", *New York Times*, 17. Juni 2001

[2] Während Skulpturen aus der Serie *Banality* wie *Michael Jackson and Bubbles* bei Auktionen Rekordsummen erzielten (5,6 Millionen Dollar im Mai 2000), verschwanden viele von Koons' Zeitgenossen völlig vom Markt.

[3] Z. B. Paul McCarthy, *Michael Jackson White*, *Michael Jackson Black* und *Michal Jackson Gold* (alle Arbeiten 1997-99), die in der Einzelausstellung mit dem Titel „Dimensions of the Mind: The Denial and Desire in the Spectacle" bei Sammlung Hauser und Wirth, St. Gallen, Schweiz, 1999 ausgestellt waren.

[4] Ein detaillierter Bericht dieser Zeit findet sich in: Ingrid Sichy, „Koons, High and Low". *Vanity Fair* (März 2000), S. 226-277.

[5] ebd. Sichy, S. 275.

[6] Nachdem die Ausstellung zwischen 1996 und 1998 viermal verschoben worden war, wurde sie in eine Retrospektive des Gesamtwerks umgewandelt, deren Eröffnungstermin irgendwann zwischen 2003 und 2004 liegen soll.

[7] David Sylvester, „Jeff Koons Interviewed", *Easyfun – Ethereal*, Ausst.kat., Deutsche Guggenheim, Berlin, 2000, S. 23-24

[8] Jeff Koons und James Rosenquist, „If You Get a Little Red on You, It Don't Wipe Off", *Parkett*, Nr. 58, 2000, S. 36-43.

[9] Robert Rosenblum, „Dream Machine", *Easyfun – Ethereal*, Ausst.kat., Deutsche Guggenheim, Berlin, 2000, S. 49-51.

[10] ebd. Rosenblum, S. 51.

[11] ebd. Sylvester, S. 17.

[12] ebd. Sylvester, S. 21.

[13] Christian Viveros-Fauné, „Koons Age: A Review of Easyfun", *New York Press*, 8.-14. Dezember 1999

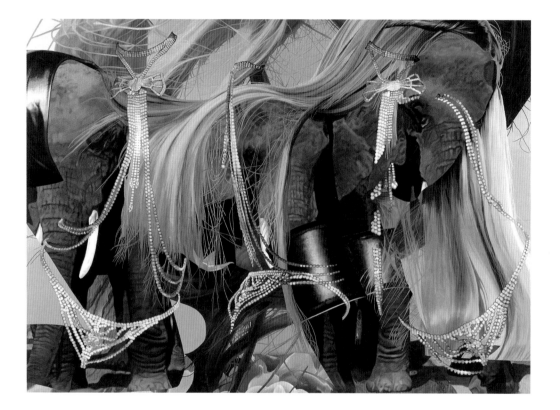

**Elephants 2001**, aus der Serie **Easyfun – Ethereal**

# Easyfun

MIT EASYFUN WAR ICH IMSTANDE,

MICH VON DEN GRENZEN ZU BEFREIEN,

DIE ICH MIR BEI CELEBRATION

SELBST AUFERLEGT HATTE.

Jeff Koons

Bear (Dark Green)  1999

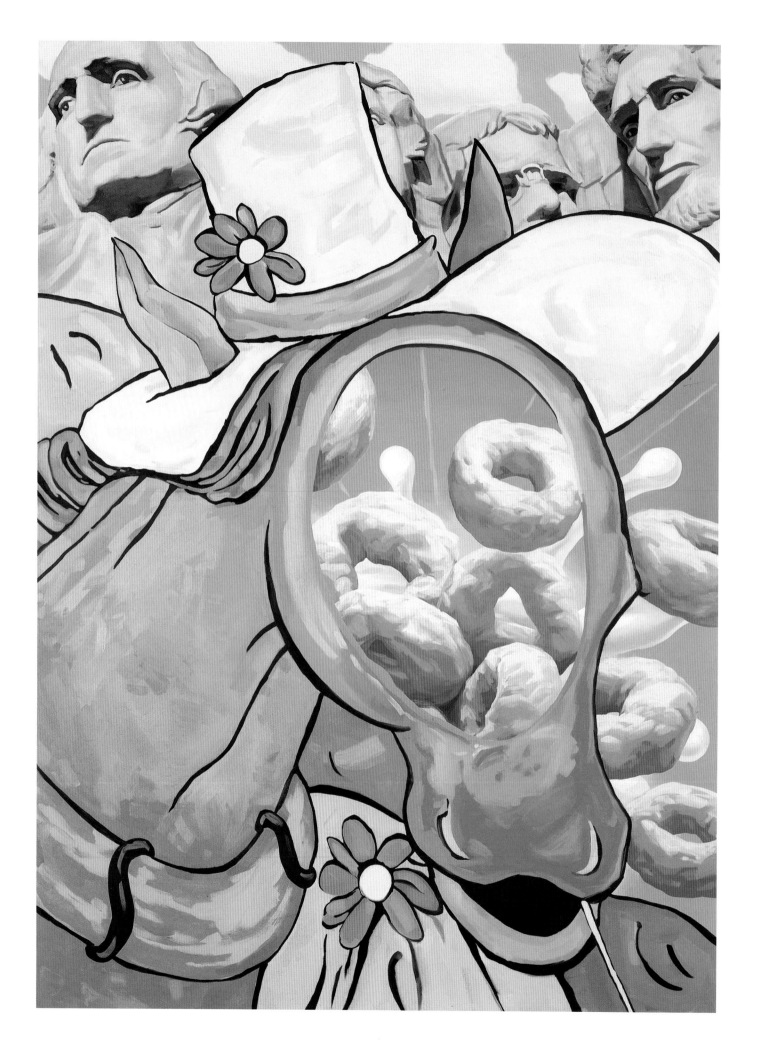

**Giraffe (Light Brown) 1999**

links *left* **Cut-Out 1999**

Hippo (Dark Pink)  1999

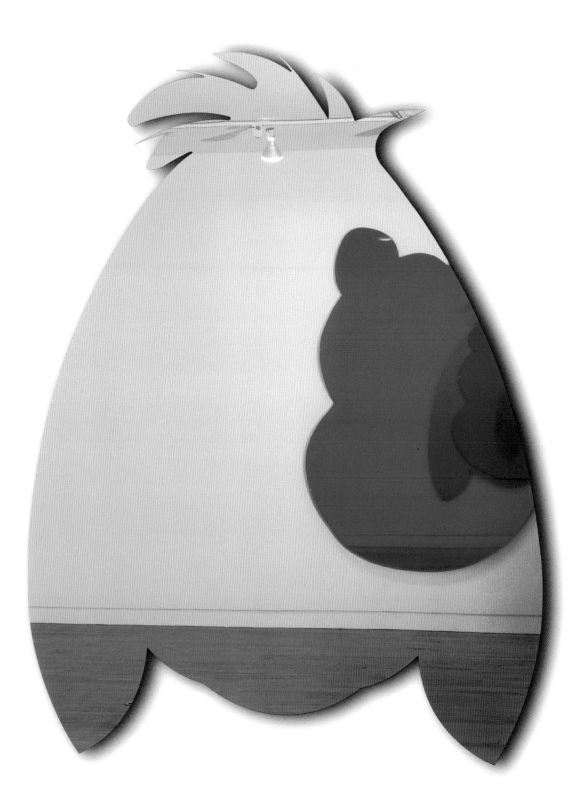

Donkey 1999

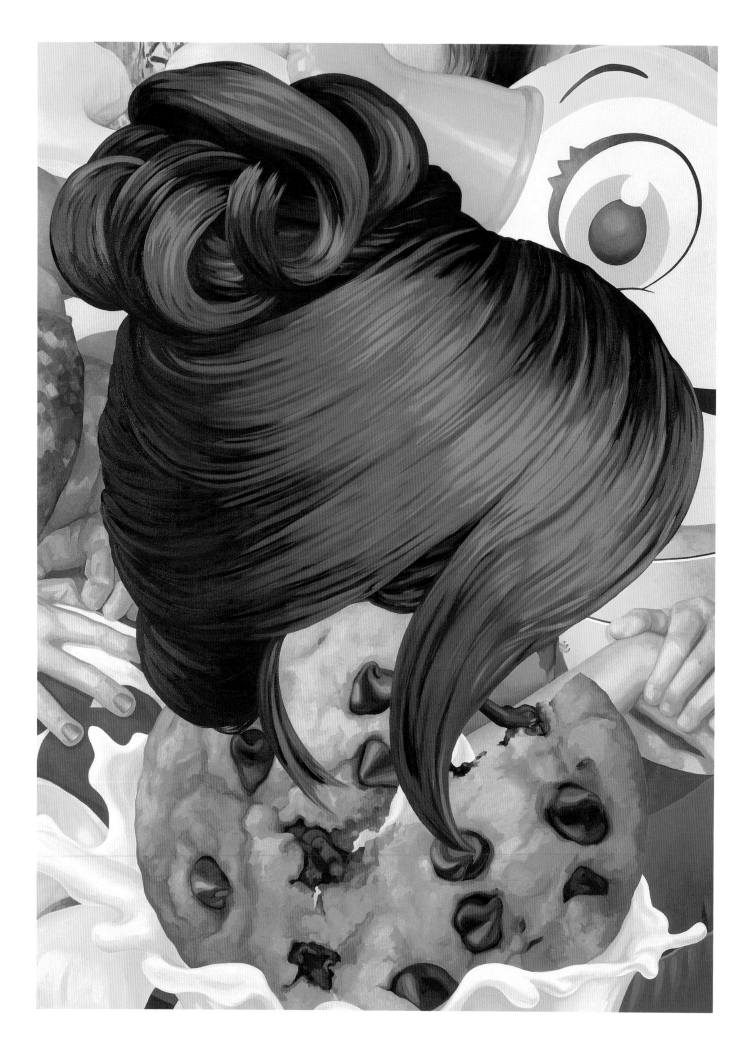

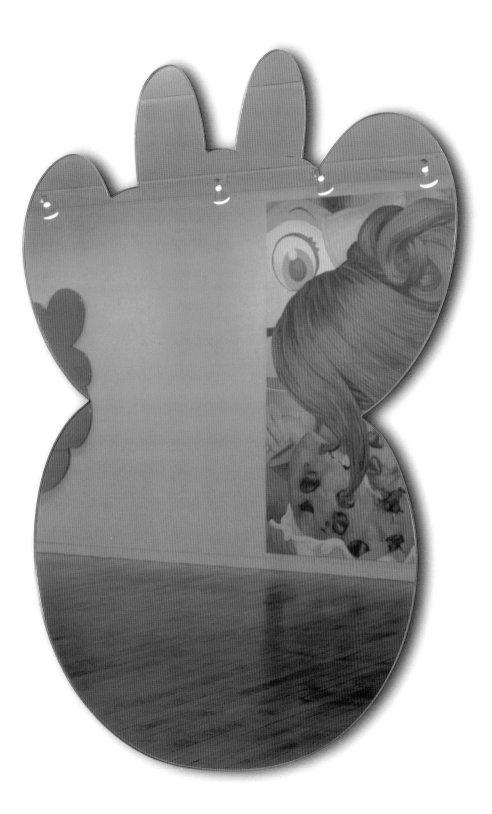

Cow (Lilac) 1999

links *left* **Hair 1999**

Walrus (Red)  1999

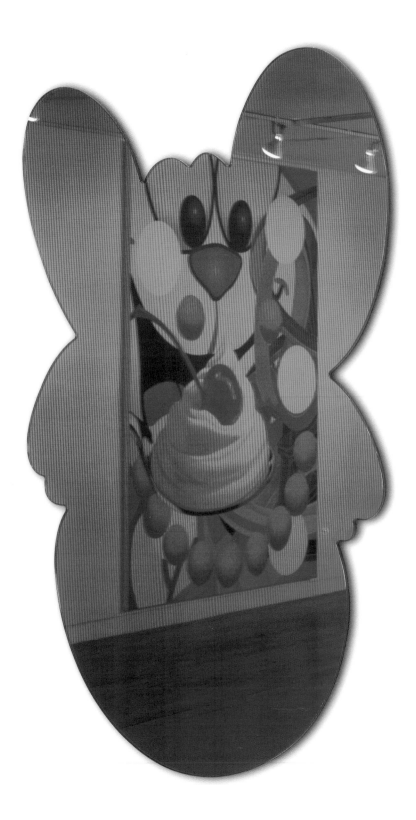

Goat (Dark Pink) 1999

rechts *right* Loopy 1999

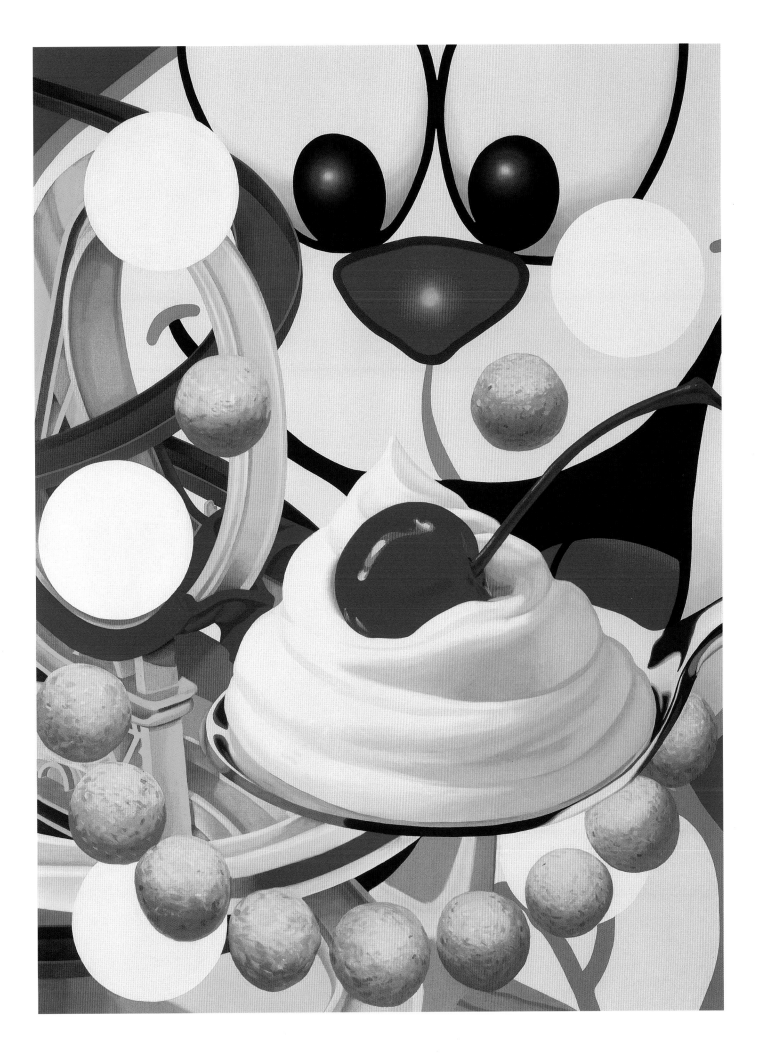

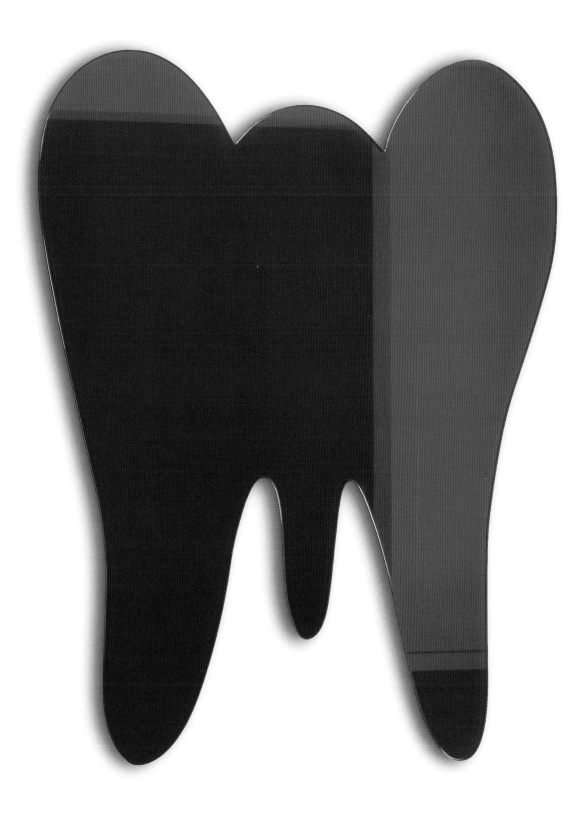

Elephant (Dark Blue) 1999

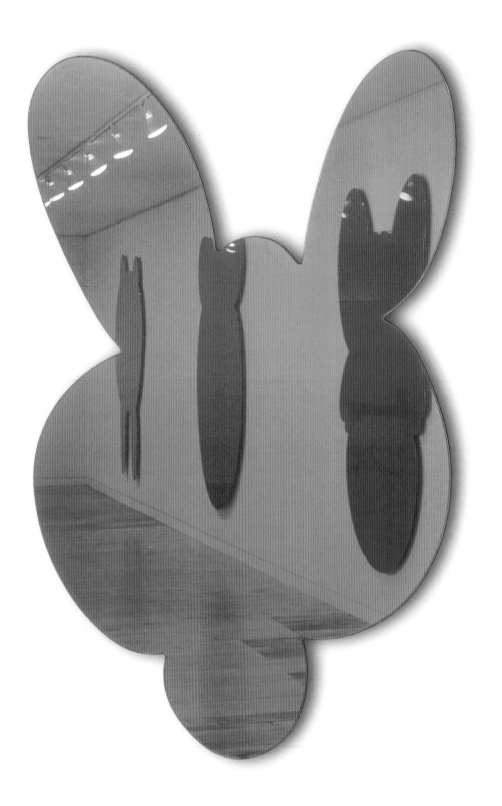

**Kangaroo (Orange)  1999**

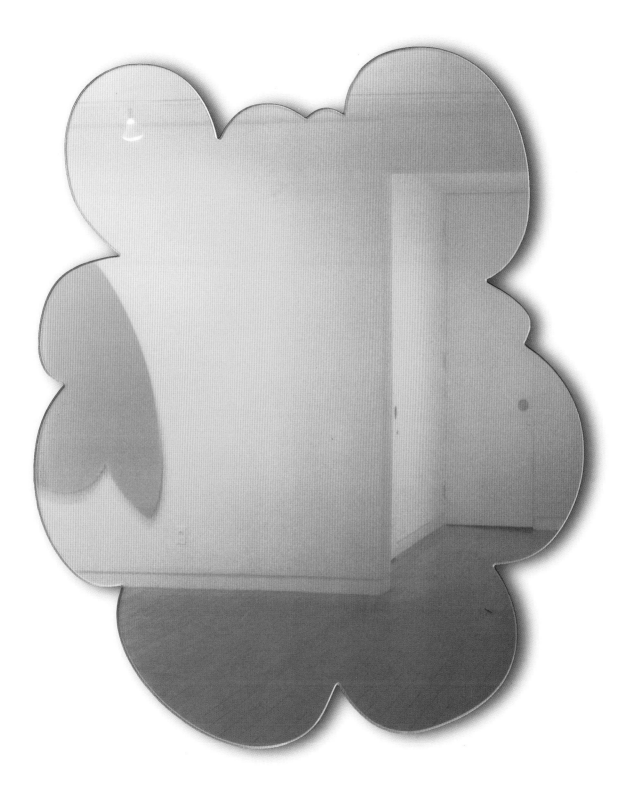

**Sheep (Yellow) 1999**

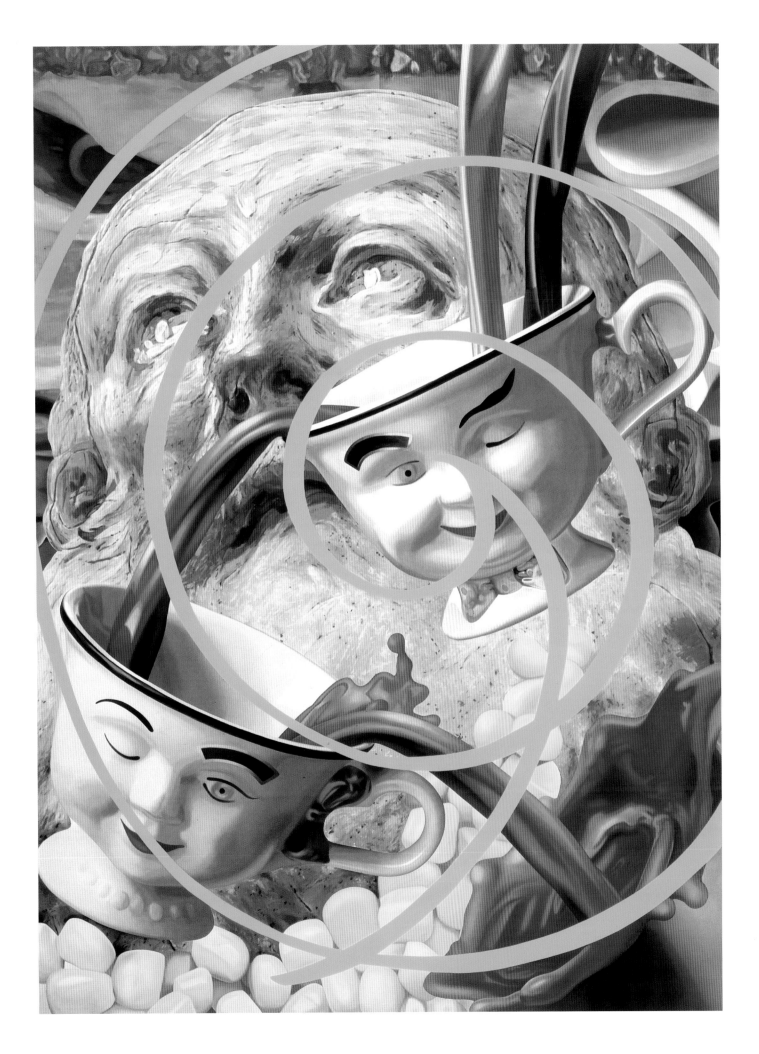

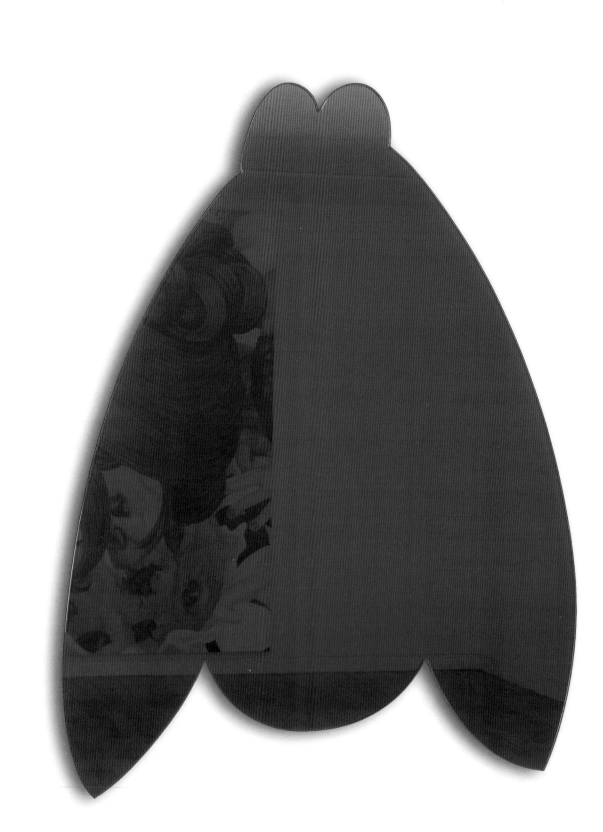

Donkey (Orange)  1999

Alison Gingeras

## THE COMEBACK OF SINCERITY: JEFF KOONS 1995-2001

### The anatomy of a comeback

A meteoric rise, an inevitable fall from grace, a difficult period of atonement, a glorious re-surrection. Gripped by the ever-growing cult of celebrity, the comeback story is one of America's favorite genres. From cable television's most popular show, VH1's soft-edge documentaries of near forgotten pop stars, *Behind the Music*, to the *New York Times* recent feature article about the downtown art scene's recent (re)embrace of Rob Pruitt – bad boy artist accused of politically incorrect address of racial issues in the early 1990s, causing his completely exile from the art world for over seven years – a compelling comeback story has two key components.

First and foremost, most comebacks are dependent on the constantly changing tides of fashion. The cyclical returns of once forgotten or obsolete trends in popular culture can complete rehabilitate an individual career or official dead style or category. Fashion designer's recent shying to the two extreme poles of the 1980s – the nouveau riche glamorous excess epitomized by *Dynasty* (Steven Meisel's campaign for Versace) or the edgy street look (Anne Demulsteer's elegant re-visitation of post-punk) – has gone hand in hand with the return of New Wave and post punk music of the same period. The current fascination and nostalgia for Duran Duran or Depeche Mode on MTV finds an echo in the art world, in exhibitions such as PS1's 1984, or Hollywood's recent bringing Bret Easton Ellis's eighties opus *American Psycho* to the silver screen – it is part of a larger process of cultural re-territorialization.

The second essential component of a successful comeback story is a sincere and lengthy act of contrition on the part of the fallen star. In the case of Rob Pruitt, the scathing reception of his show entitled *Red, Black, Green, Red, White and Blue* (Leo Castelli Gallery, 1992) caused a total eclipse of his career. At a moment when the art world was waking up with a "Neo Geo" hangover, Pruitt and his then collaborator Jack Early were accused of pure cynicism, and, more detrimentally, were considered racist. Yet as Pruitt admits in the *NY Times's* glowing chronicle of his recent comeback, his re-acceptance in the art world is hinged on his admission that the controversial Castelli show was provocative but poorly timed. "We wanted to point out the commodification of black heroes by predominantly white-owned companies, but we didn't realize what a land mine it was," Pruitt said. "At the time, the art world was very sensitive to identity issues and political correctness, but you could only be an authority if you were talking about who you were and where you came from." After this public avowal of remorse, Pruitt has adeptly used "coy humility" and "a dash of humor and Martha Stewart practicality to the traditionally austere genre of conceptual art" to wriggle his way back in to the hearts of New York art audiences.[1]

Beyond an illustration of the anatomy of comeback, Pruitt's story provides an interesting segue into the recent twists and turns of the reception of another supposed "bad boy", Jeff Koons. After his most notorious body of work *Made in Heaven* (1989-92) and the unveiling of the monumental topiary sculpture *Puppy* outside of Kassel in 1992, Koons took a seven-year hiatus from the public eye. Despite the controversy generated by the "pornographic" content in *Made in Heaven*,

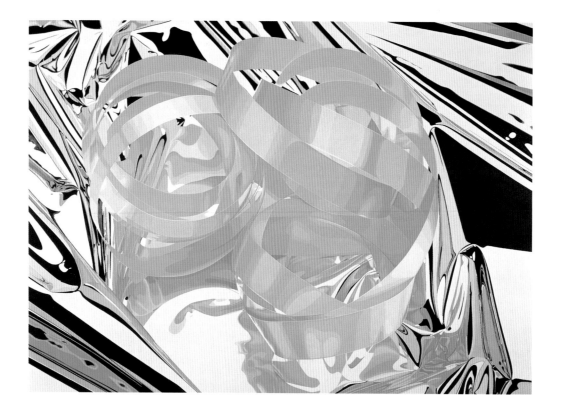

**Ribbon  1995-97**, aus der Serie **Celebration**

the reason for Koons's near absence did not stem from moral backlash. Nor was it sparked by a violent shift in fashion or taste – while Koons might be strongly identified with a generation of artists in the 1980s (Bickerton, Halley, Salle, Steinbach, etc.), his importance extends far beyond this now caricaturized moment of art production. If anything, the past decade has confirmed Koons's significance. On a financial register, the astronomical market value of Koons's "classic" works[2] has broken auction records, while many of his contemporaries have slipped into obscurity. From Paul McCarthy and Charles Ray to Dan Graham, a host of established artists clearly articulated the central importance of Koons's œuvre for their own seemingly divergent art practices. Some going so far as to directly "copy" him.[3] In the absence of art world sin or an unfashionable turn, why did Jeff Koons seem to temporarily disappear? Why is it that the works spanning 1995 to the present that comprise the Kunsthaus Bregenz exhibition could be read as part of his own comeback story?

## The *Celebration* Saga

Many journalists have relished telling the dramatic story of events that unfolded in Koons's life since the birth of his son Ludwig Koons, the end of his highly publicized marriage to Ilona Staller, and their messy child custody hearings.[4] While these events should not be conflated with a more thorough reading of his work, the years that lead up to the *Celebration* series definitely marked a turning point for Koons in his art as much as in his life.

Monumental in scale and joyously effusive in spirit, Koons began to make an ambitious body of sixteen photo-realist paintings and twenty stainless steel sculptures in 1994 that drew upon the symbols and objects associated with the observance of life's rituals – birthdays, holidays and other festive occassions. *Celebration* furthers Koons's preoccupation with the objects and experiences of childhood in previous works, as well as wanting, in own words, "to communicate with my son (...) to tell him I was thinking about him all the time".[5] Each work, whether as a painting or large-scale sculpture, isolates and scrutinizes a range of party detritus, in baroque detail. A plump red balloon dog, a phallic balloon flower, a bunch of anthropomorphic balloon tulips, a perfectly generic birthday hat, a red and yellow plastic plate setting, a slice of pink and white sticky-sweet cake, a banal silver bracelet, a broken Easter egg, a dense tableau of toy figurines, a shiny pink bow, a mound of Play-Doh, a monumental morsel of popcorn.

From 1994 until 1996, an army of assistants (there were up to seventy assistants at one point[5]) filled Koons's studio in order to complete what has been his most labor-intensive and costly project to date. Despite this highly unusual mobilization of skilled labor, reminiscent of Renaissance ateliers, the deadline for the unveiling of *Celebration* at the Guggenheim Museum Soho in 1996 came and went.[6] The degree of perfection demanded by Koons for the fabrication of these gigantic, highly polished stainless sculptures (not to mention the years it took to make the paintings, that have been only recently completed), the entire body of work lay dormant for nearly two years in the studio from 1996-99. In fact, *Celebration* has still not been exhibited in its entirety and the majority of the sculptures are still in production (only one edition of *Moon*, *Balloon Dog*, and *Balloon Flower* has been completed to Koons's specifications). Despite this

fact, the works did not slip into obscurity. Many of sculptural models and paintings were pro-minently figured on the pages of *Artforum* and *Parkett*, making Koons's determination to attain nearly impossible fabrication standards (in)famous, and his absence from the exhibition circuit from 1992-1999 fodder for his comeback story.

When speaking about his nearly saga to finance his work while not sacrificing the production quality of these paintings and sculptures, Koons constantly returns to an often misunderstood concept in his work: the question of trust. "When I make an artwork, I try to use craft as a way, hopefully, to give the viewer a sense of trust. I never want anyone to look at a painting, or to look at a sculpture, and to lose trust in it somewhere."[7]

The lack of irony in Koons's words is backed up by the years of his obsessive attention (not to mention financial burden) laden upon the production specifications of the *Celebration* series. In order to cultivate this trust, the object itself must strive for formal and conceptual perfection, no matter how physically or financially difficult. Its tarnishing effect on Koons's career at then end of the 1990s seems to vouch for his credibility. While many were quick to interpret the *Celebration* saga as the moment of Koons's "fall", it has instead served as an ideal instance to evaluate the frequent accusations of cynicism as well as the formalist dismissals of the 1980s. Most "falls" are attributed to weakness, to a moral faltering, a relinquishing of a value or an ideal — except in Koons's case. His extreme sincerity, his inability to sacrifice the "sense of trust" that he fosters in his work is what has gotten him into this long and uncomfortable situation, causing his temporary absence from the art scene. After such a tale, can Koons still be considered a cold-blooded cynic? A postmodern con man? Or is **sincerity** the key to this comeback story?

### *Easyfun*: Back on the Scene

Exhibited for the first time at Sonnabend Gallery in New York in the autumn of 1999, Koons stepped back into the public arena with new body of work entitled *Easyfun*. This aptly Koonsian neologism is, like most of his enterprise, deceptively simple. What is "easyfun" anyway? A tau-tology? Can fun be hard? The work doesn't give any immediate answer to unravelling the title: fifteen new wall-mounted highly polished stainless steel sculptures lined the walls of the Sonn-abend Gallery, each one approximating the gigantic, cartoonish outline of the shape of an ani-mal's head. A light green *Monkey*, a red-hued *Walrus*, a pink *Kangaroo*, a pale yellow *Pony*, a sil-ver steel *Donkey*. Koons tells us that this zoomorphic menagerie of reflective surfaces "is sup-posed to make you feel good."

While the sculptures do not give much away in terms of the "real" subject at hand in the new body of work, the complex iconography in the three *Easyfun* paintings at Sonnabend — *Loopy*, *Hair*, and *Cut-Out* (all works, 1999) — might provide an entry point into this enigmatic chapter of Koons's comeback. Each painting in the new series (including those made after the first exhibi-tion) shares the same composition and style: a collage of apparently incongruous subjects using photo-realist perfection. These works are created using a similar method to the *Celebration* can-vases. A sort of paint-by-number technique is used. The source images are first projected onto the picture plane in order to define the general forms of the image in pencil, and then every

Ausstellung *Exhibition* **Easyfun**

Sonnabend Gallery, New York, 1999

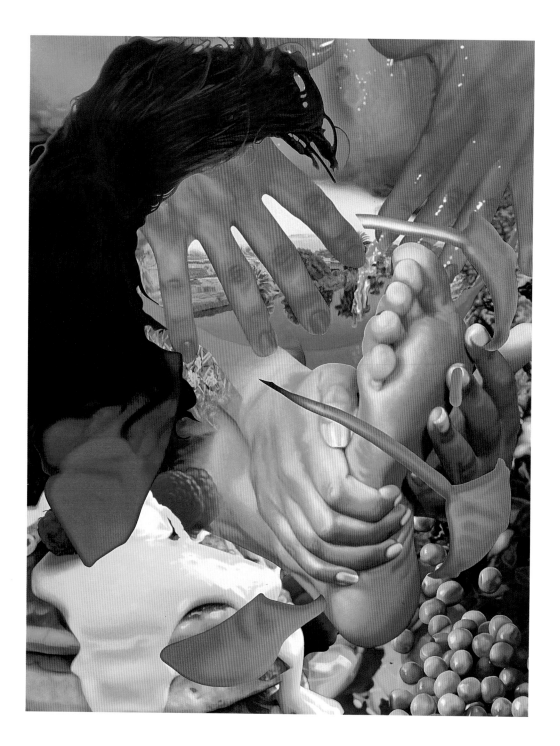

Pancakes 2001, aus der Serie **Easyfun – Ethereal**

square millimeter of surface in hand-painted to achieve the exact hues, shapes, and textures depicted in the original source photograph. Yet unlike the relentless visual scrutiny of a single object in the majority of the *Celebration* series (*Cake, Broken Egg, Bracelet*), the *Easyfun* paintings draw upon a cacophony of commercial images taken from cheap advertisements. These images could be grouped into two categories: the innocent, consumable indulgences of childhood (junk food, backyard games, amusement park rides) or the lusty pleasure's of adulthood (gaudy lace panties and bras, glittery lips and nails, perfectly tanned legs).

What would be considered pure visual pollution for most people makes up Koons extensive archive of clippings from magazines and newspapers that are seamlessly collaged together to make a densely layered pictorial space in each canvas. Stylistically, these works seem like a perfect crystallisation of American, neo avant-garde painting since 1960. The legacy of Pop is more than obvious in *Easyfun*: their pristine surfaces recall the perfectionism of Roy Lichtenstein, while their most obvious debt is owed to James Rosenquist, whose long engagement with advertising vocabulary and sign-board painting technique was acknowledged by Koons as a key reference for these works.[8] Koons's contemporary and fellow eighties art star David Salle also must be cited as an important reference in his pillaging of high and low visual culture. Yet as Robert Rosenblum has adeptly pointed out in his discussion of *Easyfun*, what distinguishes Koons from his predecessors is his revival of "the language of the most spectacularly ornate manifestations of German Baroque and Rococo art, a style that has whimsically but usefully been referred to as 'barococo'[9]."

Unlike Salle or Rosenquist, Koons's paintings are devoid of linguistic play, political commentary, or psychological charge. Their power comes from what Koons is able to subtract from these models – these works are unapologetically flat. As a counterpoint to the barococo spatial complexity and attention lavished on every detail, the subjects of these paintings are totally "empty". Human presence in the *Easyfun* paintings is reduced to fragments; there is never a "whole" subject. When the human body is evoked it is through disembodied members or the empty shell of clothing. *Pam* (2001), for example, features the sensuous crux of a woman's bent knee and a truncated segment of cleavage while *Auto* (2001) presents two pairs of parted lips adorned with gloss and a crotch shot of a woman with a pierced navel in blue bikini. In *Blue Poles* (2000), a painting from the *Easyfun – Ethereal* series, the faces of children in animal/alien Halloween costumes are replaced by a gigantic piece of breakfast cereal. Even with the recurring trope of what might be seen as a horrific fragmentation of the body, the overall tone of *Easyfun* is defiantly optimistic in its undulating forms, joyful swirls, and sensuous excess. In their embrace of "baroque ecstacy"[10], it seems reductive to read Koons's new paintings as a simple commentary on the alienation of the human subject in contemporary consumer society.

Beyond the resurrection of a *barococo* spirit and the conspicuous absence of a whole subject, what is being addressed in the *Easyfun* series? *Cut-Out*, the first painting in the series might hold the key. Perhaps most the "minimal" of Koons's recent output, *Cut Out* depicts the head of a work horse rendered in a kitsch, cartoonish manner. As the title suggests, the horse's face is cut out so that one could put their own face in the oval to have their photo taken – such two-dimensional characters are often found in amusement parks or county fairs. A burst of Cheerios breakfast

cereal (copied from the box) and a splash of milk replace the child's face that might have popped into the cutout. At the top of the composition, a fragmented image of Mount Rushmore replaces the sky. Each layer of imagery uses a slightly different style of realism or illustration style, heightening a sense of dissonance in both form and subject. When peripherally talking about *Cut-Out*'s relationship to "identity", Koons admits, "my work is about the viewer more than anything else. My work creates a support system for people to feel good about themselves and to have confidence in themselves (...) There's Mount Rushmore in the back of *Cut-Out*, that's kind of saying, 'If you want to grow up to be President...' And the cereal exploding with milk behind: that's just optimism."[11] Such comments might be too quickly dismissed as a laconic provocation or ironic response to the American Dream – the classic rags to riches tale, anyone can grow up to be president, identity is nothing but an empty vessel.

When considering *Cut-Out's* take on identity in relationship to the two-dimensional mirror sculptures in *Easyfun*, it might be more telling to take Koons at face value. In the course of the reception of the first *Easyfun* exhibition at Sonnabend, a number of critics immediately were quick to project a psychoanalytical read onto the animal mirrors. Many jumped on the Lacanian metaphor of the mirror stage and its relation to Koons's own seemingly empty subjectivity. Surely such readings over estimate the work – what could be more innocuous than a bunch of slick mirrored surfaces? The answer is both "yes" and "no". This is not the first time Koons strategically played naïve. While mining the supposedly regressive objects and images of childhood (*Easyfun*'s overly simplified animal silhouettes, sticky sweet food products, regressive heterosexuality), Koons systematically refuses sociological, psychological, or other critical reading of his work – either in terms of his own intent or as "valid" interpretation. While he openly flirts with these possible associations, his subject choices are never naïve, just transparent.

When contemplating *Bear* or *Donkey*, the viewer is confronted first and foremost with their own likeness in the mirror. The work itself gives nothing away. As Koons says, "its about being able to create a work that helps liberate people from judgment."[12] Instead of creating stable meaning or fixed judgment, Koons earnestly attempts to deflate the traditional, humanist expectations of art. Understood as an **opacity machine**, his work builds up layer after layer of transparent or legible associations build up to the point that no interpretation can stick. (The layers just pile up: Yes, you can grow up to be President! Yes, these mirrors are about the process of subject formation! Yes, these paintings are about consumer society!). Any definitive or fixed elucidation (sociological, political) slides off because Koons's paintings and sculptures do not offer any ideological grips. Being open and simultaneously empty (purged of pathos and criticality), *Easyfun* is an impenetrable object that serves to unveil the societal expectation of art. Our expectation for an underlying "meaning" of his work remains opaque – Koons acutely sets into motion a chain reaction of frustration. Humanism's expectation for soul, authenticity, and any other critical messages is denied. The opacity produced is a smokescreen, diverting our attention from the meaning of the object to the values and contradictions of the system in which it is produced.

The effectiveness of this opacity machine is clear when considering the first reviews of *Easyfun* to appear in printed media. Christian Viveros-Fauné writes in the New York Press, "Koons's works act like empty vessels, sucking up all innocent observation, draining every drop of legitimacy

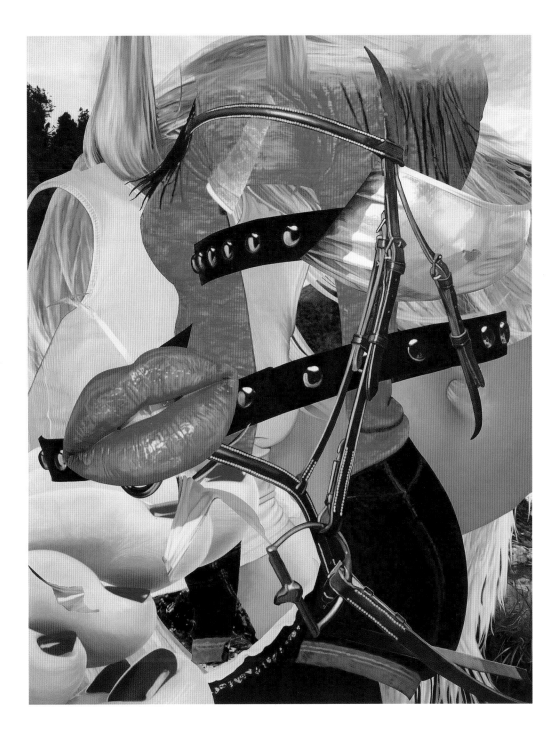

Stream 2001, aus der Serie **Easyfun − Ethereal**

available from the white cube, and scrubbing clean the decadent money-obsessed museum culture that insists on celebrating the farce that is his artmaking."[13] While these accusations are nothing new for Koons, such writing proves that he is still able to effectively prod the critic into a reactive retreat into the myths of high modernism. Viveros-Fauné's (and at least half of those present at the Sonnabend opening) lament the loss of "innocence", "legitimacy", and the "decadence" of art capital. These hypocritical cries – Who can really claim to be unsoiled by the hunt for capital (monetary, intellectual or otherwise)? Who really believes in this kind of legitimacy? What values are underlying these reproaches? – keenly draw out the contradiction between the "high" expectations of art's effects and the "dirty" power relations necessary to the art world's survival.

Perhaps the trap that Koons sets for critics is more effective than such self-proclaimed political artists such as Hans Haacke who use reportage techniques in order to unmask the dubious business associations of trustees of the Museum of Modern Art or art world mogul Peter Ludwig. Contingent on his subversive sincerity, Koons in his insistence on "trust" just might be a political artist after all.

If nothing else, *Easyfun* concludes the chapter of Koons's return to the world of contemporary art. Sincerity – smoke-screens, not cynicism – is his key to reaching affect as well as to adding a twist to his own comeback story.

Alison M. Gingeras is Curator for Contemporary Art at Musée national d'art moderne, Centre Pompidou, Paris.

[1] Mia Fineman. "Back In The Arms Of The Art World." *New York Times*, June 17, 2001.

[2] While sculptures from the *Banality* series such as *Michael Jackson and Bubbles* reached record prices at auction ($ 5.6 million in May 2000), many of Koons's contemporaries have completely disappeared from the market.

[3] See for example, Paul McCarthy, *Michael Jackson White*, *Michael Jackson Black*, and *Michael Jackson Gold* (all works, 1997-99), exhibited in the solo exhibition entitled "Dimensions of the Mind: The Denial and Desire in the Spectacle", Sammlung Hauser und Wirth, St. Gallen, Switzerland, 1999.

[4] For a detailed account of this period, see: Ingrid Sichy. "Koons, High and Low." *Vanity Fair* (March 2000), pp. 226-277.

[5] ibid. Sichy, p. 275.

[6] After being postponed four times 1996-1998, the exhibition was transformed into a full-scale retrospective that is scheduled sometime between 2003-4.

[7] David Sylvester. "Jeff Koons Interviewed." *Easyfun – Ethereal* (exh. cat.) Deutsche Guggenheim Berlin (2000), pp. 23-24.

[8] Jeff Koons and James Rosenquist, "If You Get a Little Red on You, It Don't Wipe Off," *Parkett*, no. 58 (2000), pp. 36-43.

[9] Robert Rosenblum. "Dream Machine" *Easyfun – Ethereal* (exh. cat.) Deutsche Guggenheim Berlin (2000), pp. 49-51.

[10] ibid. Rosenblum, p. 51.

[11] ibid. Sylvester, p. 17.

[12] ibid. Sylvester, p. 21.

[13] Christian Viveros-Fauné. "Jeff Koons: A Review of Easyfun", *New York Press*, 8-14 December 1999

# EASY FUN – ETHEREAL

DIE BILDER DER EASYFUN – ETHEREAL

SERIE HABEN MEHRERE

BEDEUTUNGSSCHICHTEN. ICH WOLLTE

IMMER KUNST MACHEN, DIE SICH MIT

DEM KULTURELLEN UMFELD DES

BETRACHTERS ÄNDERT. WENN MIR DIE

GESCHICHTLICHEN BEZÜGE IN DEN

BILDERN BEWUSST WERDEN, HABE ICH

MANCHMAL FÜR EINEN MOMENT DAS

GEFÜHL, DASS SICH DAS EGO IN DER

FLUT DER ZUSAMMENHÄNGE VERLIERT.

Jeff Koons

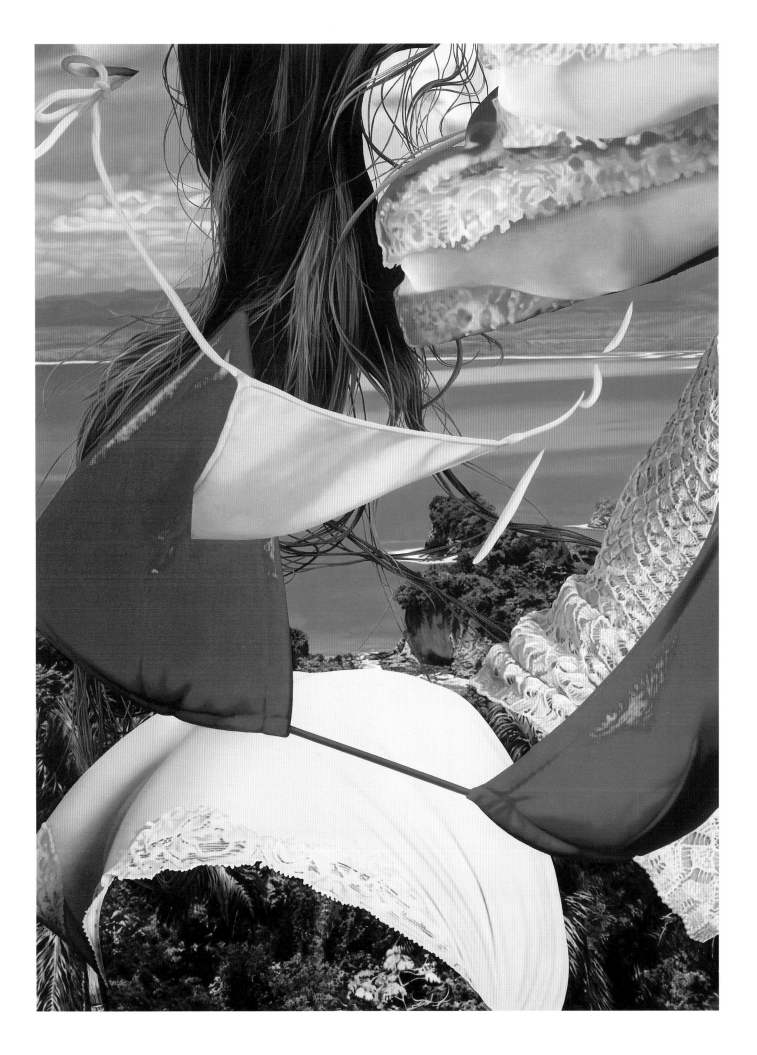

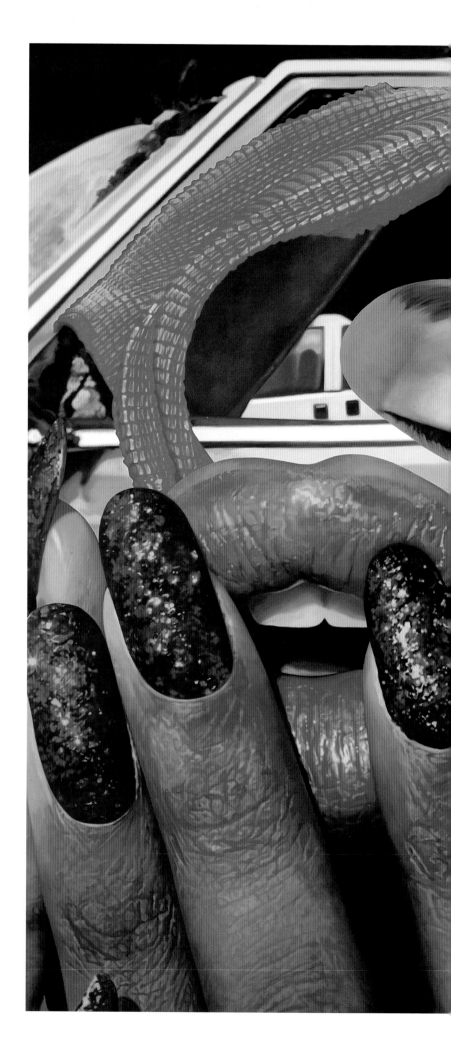

Auto 2001

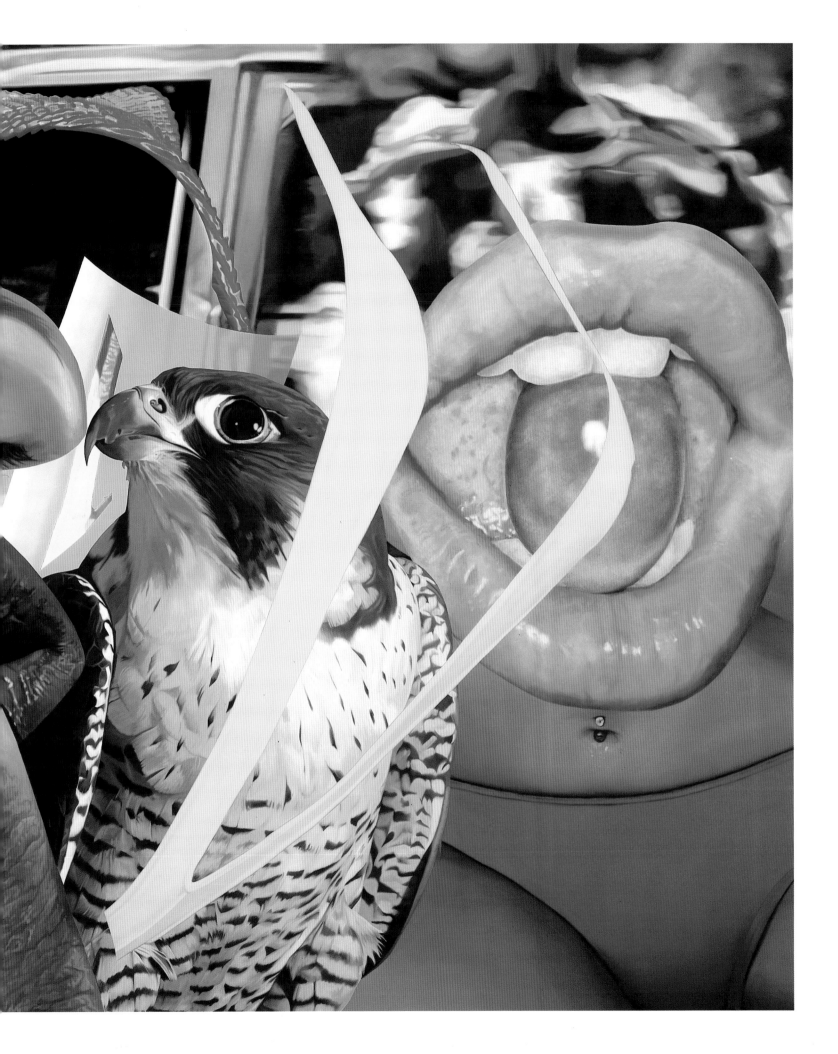

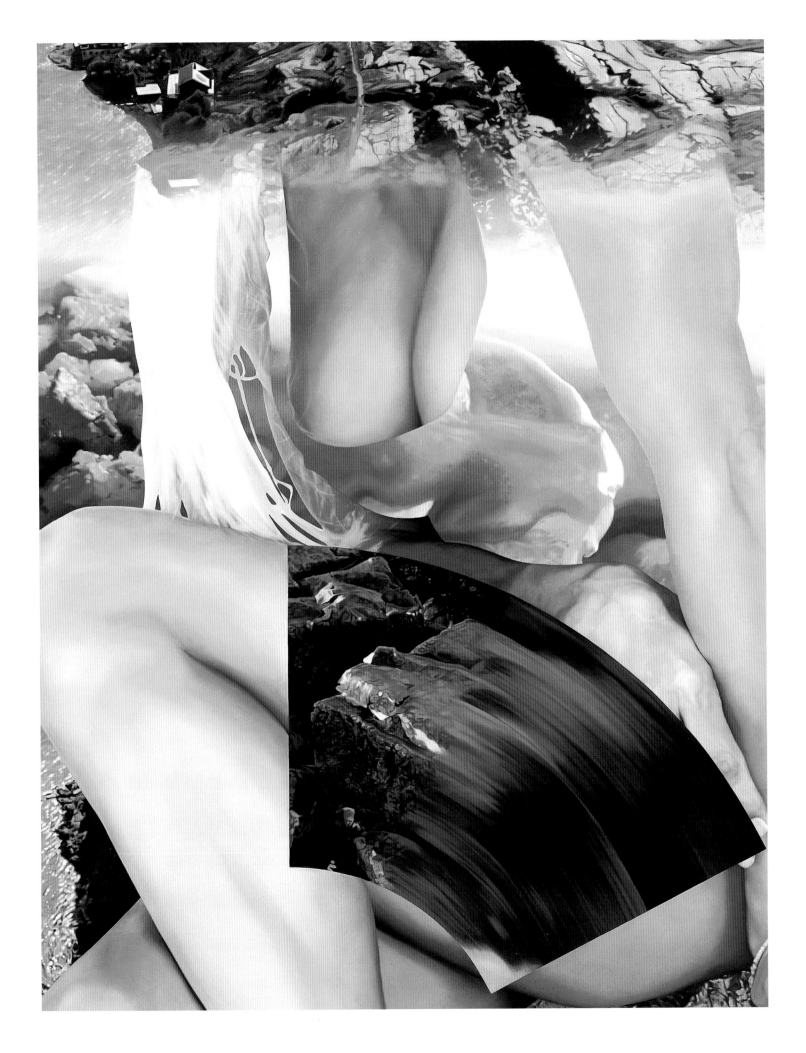

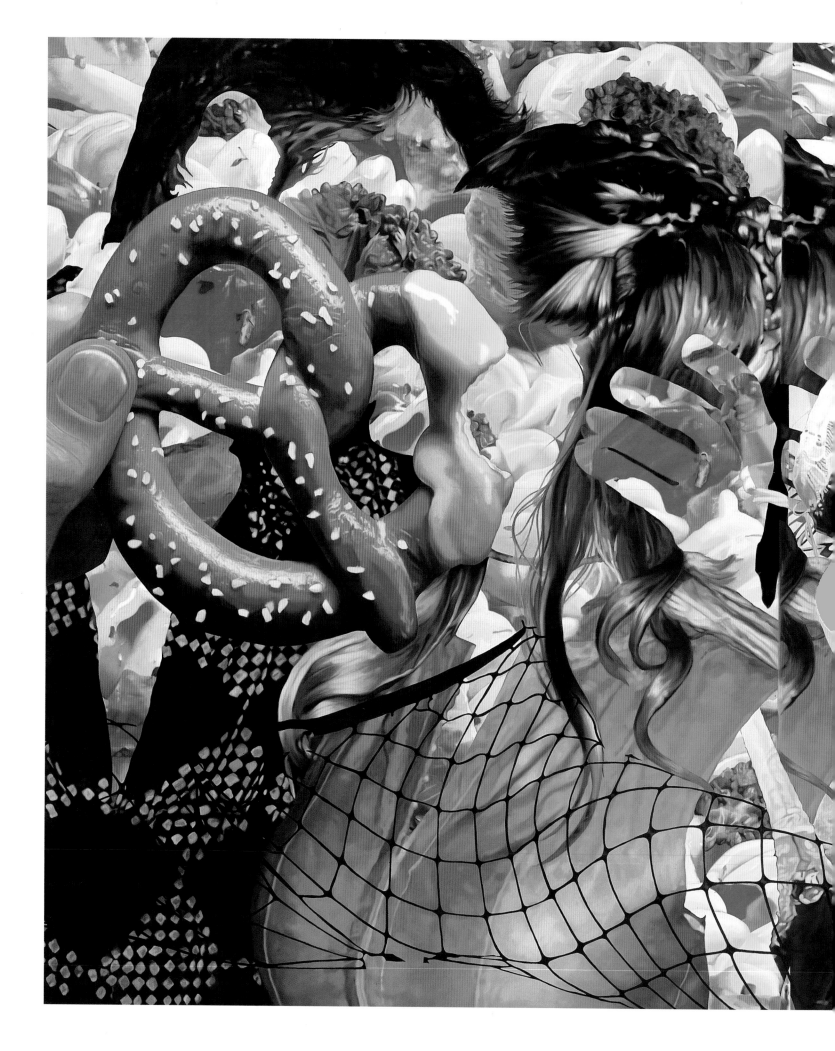

Couple 2001

Candle 2001

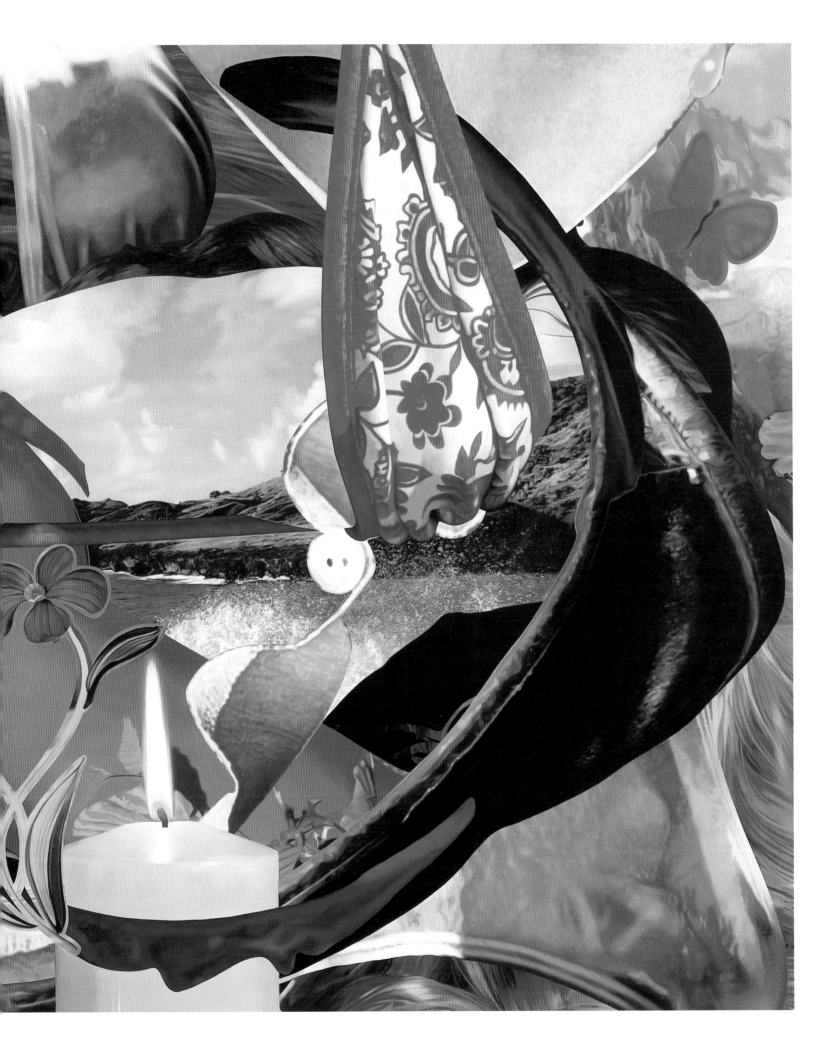

# VERZEICHNIS DER AUSGESTELLTEN ARBEITEN *LIST OF EXHIBITED WORKS*

## CELEBRATION

**Balloon Dog** 1995-98
Öl auf Leinwand *Oil on canvas*
259,1 x 363,2 cm

Sammlung *Collection of* Norah und Norman Stone, San Francisco
Courtesy Thea Westreich Art Advisory Services, New York

**Bracelet** 1995-98
Öl auf Leinwand *Oil on canvas*
265,1 x 355,0 cm

Courtesy of Anthony d'Offay Gallery, London

**Bread with Egg** 1995-97
Öl auf Leinwand *Oil on canvas*
325,1 x 274,3 cm

Courtesy of Anthony d'Offay Gallery, London

**Hanging Heart** 1995-98
Öl auf Leinwand *Oil on canvas*
332,7 x 254,0 cm

Courtesy The Dakis Joannou Collection Foundation, Athen *Athens*

**Pink Bow** 1995-97
Öl auf Leinwand *Oil on canvas*
270,5 x 346,4 cm

Sammlung Scharpff in der Hamburger Kunsthalle *Scharpff Collection at Hamburger Kunsthalle*

**Plate Set** 1995-98
Öl auf Leinwand *Oil on canvas*
319,4 x 295,0 cm

Sammlung *Collection of* Dimitris Daskalopoulos, Griechenland *Greece*

# EASYFUN

## PAINTINGS

**Cut-Out** 1999
Öl auf Leinwand *Oil on canvas*
274,5 x 201,3 cm

Sammlung *Collection of* Davide Halevim,
Mailand *Milan*
Courtesy No Limits Gallery, Mailand *Milan*

**Saint Benedict** 2000
Öl auf Leinwand *Oil on canvas*
274,3 x 201,3 cm

Sammlung *Collection of* Stefan T. Edlis,
Chicago

## MIRRORS

**Bear (Dark Green)** 1999
Kristallglas, Spiegelglas, farbiges Plastik,
Edelstahl *Crystal glass, mirrored glass,
colored plastic interlayer, stainless steel*
212,4 x 152,1 x 4,5 cm

Courtesy Giorgio Bassi, Mailand *Milan*

**Donkey** 1999
Spiegelpolierter Edelstahl
*Mirror-polished stainless steel*
198,1 x 152,4 x 3,2 cm

Privatsammlung *Private Collection*, Belgien
*Belgium*

**Giraffe (Light Brown)** 1999
Kristallglas, Spiegelglas, farbiges Plastik,
Edelstahl *Crystal glass, mirrored glass,
colored plastic interlayer, stainless steel*
210,8 x 152,7 x 4,5 cm

Courtesy No Limits Gallery, Mailand *Milan*

**Hippo (Dark Pink)** 1999
Kristallglas, Spiegelglas, farbiges Plastik,
Edelstahl *Crystal glass, mirrored glass,
colored plastic interlayer, stainless steel*
211,5 x 150,5 x 4,5 cm

Courtesy The Brant Foundation, Greenwich,
Connecticut

**Kangaroo (Orange)** 1999
Kristallglas, Spiegelglas, farbiges Plastik,
Edelstahl *Crystal glass, mirrored glass,
colored plastic interlayer, stainless steel*
232,4 x 149,6 x 4,5 cm

Sammlung des Künstlers *Collection of the artist*
Courtesy of Sonnabend Gallery, New York

**Monkey (Blue)** 1999
Kristallglas, Spiegelglas, farbiges Plastik,
Edelstahl *Crystal glass, mirrored glass,
colored plastic interlayer, stainless steel*
177,0 x 153,2 x 4,5 cm

Courtesy of Sonnabend Gallery, New York

**Walrus (Purple)** 1999
Kristallglas, Spiegelglas, farbiges Plastik,
Edelstahl *Crystal glass, mirrored glass,
colored plastic interlayer, stainless steel*
225,4 x 152,1 x 4,5 cm

Sammlung des Künstlers *Collection of the artist*
Courtesy of Sonnabend Gallery, New York

## EASYFUN – ETHEREAL

**Auto**  2001
Öl auf Leinwand *Oil on canvas*
259,1 x 350,1 cm

Courtesy of Gagosian Gallery, New York

**Beach**  2001
Öf auf Leinwand *Oil on canvas*
274,3 x 213,4 cm

Privatsammlung *Private Collection*, New York
Courtesy Thea Westreich Art Advisery Services,
New York

**Candle**  2001
Öl auf Leinwand *Oil on canvas*
304,8 x 426,7 cm

Courtesy of Gagosian Gallery, New York

**Cheeky**  2000
Öl auf Leinwand *Oil on canvas*
274,3 x 201,3 cm

Sammlung *Collection of* Norah und Norman
Stone, San Francisco
Courtesy Thea Westreich Art Advisory Services,
New York

**Couple**  2001
Öl auf Leinwand *Oil on canvas*
259,1 x 350,1 cm

Courtesy The Broad Art Foundation, Santa
Monica

**Pam**  2001
Öl auf Leinwand *Oil on canvas*
274,3 x 213,4 cm

Courtesy of Gagosian Gallery, New York

**Cow (Lilac)**  1999
aus der Serie *from the series* **Easyfun**
Kristallglas, Spiegelglas, farbiges Plastik,
Edelstahl *Crystal glass, mirrored glass,
colored plastic interlayer, stainless steel*
203,2 x 150,5 x 4,5 cm

Privatsammlung *Private collection*

**Desert**  2001
aus der Serie *from the series*
**Easyfun – Ethereal**
Öl auf Leinwand *Oil on canvas*
274,3 x 213,4 cm

Courtesy of Gagosian Gallery, New York

**Donkey (Orange)**  1999
aus der Serie *from the series* **Easyfun**
Kristallglas, Spiegelglas, farbiges Plastik,
Edelstahl *Crystal glass, mirrored glass,
colored plastic interlayer, stainless steel*
192,8 x 149,5 x 4,5 cm

Privatsammlung *Private collection*

**Elephant (Dark Blue)**  1999
aus der Serie *from the series* **Easyfun**
Kristallglas, Spiegelglas, farbiges Plastik,
Edelstahl *Crystal glass, mirrored glass,
colored plastic interlayer, stainless steel*
193,7 x 149,5 x 4,5 cm

Privatsammlung *Private collection*, Italien *Italy*

**Elephants**  2001
aus der Serie *from the series*
**Easyfun – Ethereal**
Öl auf Leinwand *Oil on canvas*
304,8 x 426,7 cm

Courtesy of Gagosian Gallery, New York

**Goat (Dark Pink)** 1999
aus der Serie *from the series* **Easyfun**
Kristallglas, Spiegelglas, farbiges Plastik,
Edelstahl *Crystal glass, mirrored glass,
colored plastic interlayer, stainless steel*
218,8 x 150,2 x 4,5 cm

Sammlung *Collection of* Patricia und Pippo
Giardiello, Neapel *Naples*

**Hair** 1999
aus der Serie *from the series* **Easyfun**
Öl auf Leinwand *Oil on canvas*
274,3 x 201,3 cm

Privatsammlung *Private collection*

**Inflatable Flower and Bunny** 1979
aus der Serie *from the series* **The Pre-New**
Plastik, Spiegel, Plexiglas
*Plastic, mirrored glass, plexiglass*
63,5 x 40,6 x 45,7 cm

Privatsammlung *Private collection*

**Loopy** 1999
aus der Serie *from the series* **Easyfun**
Öl auf Leinwand *Oil on canvas*
274,3 x 201,3 cm

Sammlung *Collection of* Angela und Massimo
Lauro, Neapel *Naples*

**Pancakes** 2001
aus der Serie *from the series*
**Easyfun – Ethereal**
Öl auf Leinwand *Oil on canvas*
274,3 x 213,4 cm

Courtesy of Gagosian Gallery, New York

**Play-Doh** 1995-2000
aus der Serie *from the series* **Celebration**
Öl auf Leinwand *Oil on canvas*
340,0 x 280,0 cm

Privatsammlung *Private collection*

**Ribbon**  1995-97
aus der Serie *from the series* **Celebration**
Öl auf Leinwand *Oil on canvas*
259,0 x 363,0 cm

Courtesy Galerie Max Hetzler, Berlin

**Sheep (Yellow)**  1999
aus der Serie *from the series* **Easyfun**
Kristallglas, Spiegelglas, farbiges Plastik,
Edelstahl *Crystal glass, mirrored glass,
colored plastic interlayer, stainless steel*
179,5 x 149,5 x 4,5 cm

Privatsammlung *Private collection*

**Stream**  2001
aus der Serie *from the series*
**Easyfun – Ethereal**
Öl auf Leinwand *Oil on canvas*
274,3 x 213,4 cm

Courtesy of Gagosian Gallery, New York

**Tulips**  1995-98
aus der Serie *from the series* **Celebration**
Öl auf Leinwand *Oil on canvas*
282,7 x 331,9 cm

The Dakis Joannou Collection Foundation,
Athen *Athens*

**Walrus (Red)**  1999
aus der Serie *from the series* **Easyfun**
Kristallglas, Spiegelglas, farbiges Plastik,
Edelstahl *Crystal glass, mirrored glass,
colored plastic interlayer, stainless steel*
225,5 x 152,1 x 4,5 cm

Privatsammlung *Private collection*

# JEFF KOONS

## Biografische Notiz *Biographical Note*

Geboren *Born in* York, Pennsylvania, 1955
1972-75 Maryland Institute College of Art, Baltimore, Maryland
1975-76 School of the Art Institute of Chicago, Chicago, Illinois
1976 Maryland Institute College of Art, Baltimore, Maryland, B.F.A.
Lebt *Lives* in New York

## EINZELAUSSTELLUNGEN *SOLO EXHIBITIONS*

### Auswahl *Selection*

**2001**
**Jeff Koons** Kunsthaus Bregenz
**New Paintings** Gagosian Gallery, Los Angeles

**2000**
**Easyfun – Ethereal** Deutsche Guggenheim, Berlin (Katalog *catalogue*)
**Puppy** Rockefeller Center, New York
**Split-Rocker** Papal Palace, Avignon

**1999**
**Jeff Koons. A Millennium Celebration** The Dakis Joannou Collection Foundation, Athen *Athens*
**Easyfun** Sonnabend Gallery, New York

**1998**
**Jeff Koons: Encased Works** Anthony d'Offay Gallery, London

**1997**
**Puppy** Guggenheim Museum Bilbao [ständige Sammlung *permanent collection*]
**Jeff Koons** Galerie Jérôme de Noirmont, Paris (Katalog *catalogue*)

**1995**
**Puppy** Museum of Contemporary Art, Sydney

**1994**
**Jeff Koons: A Survey 1981-1994** Anthony d'Offay Gallery, London

**1993**
**Jeff Koons Retrospective** Walker Art Center, Minneapolis; Kunstmuseum Aarhus, Dänemark
*Denmark;* Staatsgalerie Stuttgart (Katalog *catalogue*)

**1992**
**Jeff Koons Retrospective** San Francisco Museum of Modern Art; Stedelijk Museum,
Amsterdam (Katalog *catalogue*)
**Made In Heaven** Galerie Lehmann, Lausanne
**Made In Heaven** Christophe Van de Weghe, Brüssel *Brussels*

**1991**
**Made In Heaven** Sonnabend Gallery, New York, Galerie Max Hetzler, Köln *Cologne*

1989
**Jeff Koons – Nieuw Werk**  Galerie 'T Venster, Rotterdamse Kunststichting, Rotterdam

1988
**Jeff Koons**  Museum of Contemporary Art, Chicago (Katalog *catalogue*)
**Banality**  Sonnabend Gallery, New York; Galerie Max Hetzler, Köln *Cologne*;
Donald Young Gallery, Chicago

1987
Daniel Weinberg Gallery, Los Angeles

1986
International With Monument Gallery, New York
Daniel Weinberg Gallery, Los Angeles

1985
International With Monument Gallery, New York
Feature Gallery, Chicago, Illinois

1980
**The New**  (Fensterinstallation *window installation*), The New Museum of Contemporary Art,
New York

## GRUPPENAUSSTELLUNGEN *GROUP EXHIBITIONS*

### Auswahl *Selection*

2001
**Collaborations with Parkett: 1984 to Now**  The Museum of Modern Art, New York
**Give & Take**  Serpentine Gallery and Victoria and Albert Museum, London (Katalog *catalogue*)

2000
**Hypermental. Wahnhafte Wirklichkeit 1950-2000. Von Salvador Dali bis Jeff Koons** *Hyper-
mental, rampant reality, 1950-2000: from Salvador Dali to Jeff Koons*  Kunsthaus Zürich;
2001 Hamburger Kunsthalle, Hamburg (Katalog *catalogue*)
**Au-delà du spectacle**  Centre Pompidou, Paris (Katalog *catalogue*)
**Actual Size**  Museum of Modern Art, New York
**MoMA 2000**  Museum of Modern Art, New York
**Matter**  Museum of Modern Art, New York
**Pop and After**  Museum of Modern Art, New York
**Innocence and Experience**  Museum of Modern Art, New York
**Apocalypse: Beauty & Horror in Contemporary Art**  Royal Academy of Arts, London
(Katalog *catalogue*)
**Almost Warm and Fuzzy**  Tacoma Art Museum, Tacoma, Washington
**Around 1984 A Look at Art in the Eighties**  P.S.1, New York
**Let's Entertain**  Portland Museum of Art, Portland, Maine
**Sonnabend Retrospective**  Sonnabend Gallery, New York
**La Beauté. Expositions en Avignon**  Avignon, Frankreich *France*
**Sculpture**  James Cohan Gallery, New York
**Inner Eye**  Neuberger Museum of Art, New York

1999
**A Celebration of Art**  25th Anniversary of the Hirshhorn Museum and Sculpture Garden,
Washington, D.C.
**The American Century, Part II**  Whitney Museum of American Art, New York
**Transmute**  Museum of Contemporary Art, Chicago
**Gesammelte Werke 1 – Zeitgenössische Kunst seit 1968**  Kunstmuseum Wolfsburg
(Katalog *catalogue*)
**Heaven**  Kunsthalle Düsseldorf
Tate Gallery, Liverpool
**La Casa**  Haus von *Residence of* Mauro Nicoletti, Rom *Rome* (Katalog *catalogue*)
**L'objet photographique 2**  Galerie d'art contemporain, Mourenx, Frankreich *France*
**The Virginia and Bagley Wright Collection**  Seattle Art Museum, Seattle, Washington
(Katalog *catalogue*)
**Decades in Dialogue: Perspectives on the MCA Collection**  Museum of Contemporary Art, Chicago

**Art at Work: Forty Years of The Chase Manhattan Collection**  Museum of Fine Arts and the Contemporary Arts Museum, Houston, Texas

1998

**Six Americans**  Skarstedt Fine Art, New York
**L'Envers du Décor, Dimensions décoratives dans l'art du XXe siècle**  Musée d'art moderne, Lille; Métropole, Villeneuve d'Ascq, Frankreich *France* (Katalog *catalogue*)
**A Portrait of Our Times: An Introduction to the Logan Collection**  San Francisco Museum of Modern Art
**Double Trouble. The Patchett Collection**  Museum of Contemporary Art, San Diego
**Un monde merveilleux. Kitsch et Art Contemporain**  Frac Nord - Pas de Calais, Dunkerque, Frankreich *France*
**Interno – Esterno/Alterno**  FENDI, New York (Katalog *catalogue*)
**Urban**  Tate Gallery, Liverpool
**Fast Forward: Trademarks**  Kunstverein in Hamburg
**René Magritte and the Contemporary Art**  Museum voor Moderne Kunst, Oostende, Belgien *Belgium* (Katalog *catalogue*)
**Tuning Up #5**  Kunstmuseum Wolfsburg (Katalog *catalogue*)
**Art in the 20th Century: Collection from the Stedelijk Museum Amsterdam**  Ho-Am Art Museum, Seoul, Korea (Katalog *catalogue*)

1997

**Hospital**  Galerie Max Hetzler, Berlin
**Group Show**  The Eli Broad Family Foundation, Santa Monica
**Kunst..Arbeit**  Südwest LB Forum, Stuttgart
**Dramatically Different**  Magasin - Centre National d'Art Contemporain de Grenoble, Grenoble, Frankreich *France,* (Katalog *catalogue*)
**A House is not a Home**  Center for Contemporary Art, Amsterdam
**On the Edge: Contemporary Art from the Werner and Elaine Dannheisser Collection**  The Museum of Modern Art, New York (Katalog *catalogue*)
**Envisioning the Contemporary: Selections from the Permanent Collection**  Museum of Contemporary Art, Chicago
**4e biennale d'art contemporain de Lyon: 'L'Autre'**  Lyon (Katalog *catalogue*)
**Futuro Presente Passato: La Biennale di Venezia**  Venedig *Venice,* (Katalog *catalogue*)
**Objects of Desire: The Modern Still Life**  The Museum of Modern Art, New York (Katalog *catalogue*)
**Multiple Identity: Amerikanische Kunst 1975-1995. Aus dem Whitney Museum of American Art**  Kunstmuseum Bonn; Castello di Rivoli, Museo d'Arte Contemporanea, Rivoli, Italien *Italy* (Katalog *catalogue*)

**Autoportraits** La Galerie Municipale du Château d'Eau, Toulouse, Frankreich *France*
**Family Values: American Art in the Eighties and Nineties** Sammlung Scharpff in der Hamburger
Kunsthalle *Scharpff Collection at the Hamburger Kunsthalle*, Hamburg
**Belladonna** Institute of Contemporary Arts, London
**It's Only Rock and Roll: Rock and Roll Currents in Contemporary Art** Phoenix Art Museum,
Phoenix, Arizona

1996
**Art at Home – Ideal Standard Life** Spiral Garden, Tokyo (Katalog *catalogue*)
**a/drift** Center for Curatorial Studies Museum, Bard College, Annandale-on-Hudson, New York
**Playpen & Corpus Delirium** Kunsthalle Zürich
**Just Past: The Contemporary in MOCA's Permanent Collectiotion, 1975-96** The Geffen Con-
temporary, The Museum of Contemporary Art, Los Angeles
**Art at the End of the 20th Century. Selections from the Whitney Museum of American Art**
National Gallery and Alexandros Soutzos Museum, Athen *Athens*; Museu d'Art Contemporani,
Barcelona, Kunstmuseum Bonn; (Katalog *catalogue*)
**Everything That's Interesting Is New: The Dakis Joannou Collection** Athens School of Fine Arts,
Athen *Athens*
**The Human Body in Contemporary American Sculpture** Gagosian Gallery, New York

1995
**From Christo and Jean Claude to Jeff Koons: John Kaldor Art Projects and Collection** Museum
of Contemporary Art, Sydney (Katalog *catalogue*)
**Jeff Koons / Roy Lichtenstein** The Eli Broad Family Foundation, Santa Monica
**Group Show** Organized by Jeff Koons, Nicole Klagsbrun Gallery, New York
**Black Male: Representations of Masculinity in Contemporary American Art** Whitney Museum
of American Art, New York; Armand Hammer Museum of Art and Cultural Center, UCLA, Los
Angeles (Katalog *catalogue*)
**A Collection Sculptures** Caldic Collection, Rotterdam (Katalog *catalogue*)
**Zeichen und Wunder** *Signs and Wonders* Kunsthaus Zürich; Centro Galego de Arte
Contemporánea, Santiago de Compostela, Spanien *Spain* (Katalog *catalogue*)
**A Benefit Exhibition for D.E.A.F., Inc.** Organized by Jeff Koons, Nicole Klagsbrun Gallery,
New York
**Going for Baroque** The Contemporary and the Walters Art Gallery, Baltimore, Maryland
(Katalog *catalogue*)
**Die Muse?** Galerie Thaddeaus Ropac, Salzburg
**Unser Jahrhundert** Museum Ludwig, Köln *Cologne*
**45 Nord & Longitude 0** Capc Musée d'art Contemporain de Bordeaux

**Florine Stettheimer Collapsed Time Salon** Jeffrey Deitch, The Gramercy International Art Fair, New York
**Tuning Up #3** Kunstmuseum Wolfsburg

1994
**Face Off: The Portrait in Recent Art** Institute of Contemporary Art, University of Pennsylvania, Philadelphia; Joslyn Art Museum, Omaha, Nebraska; Weatherspoon Art Gallery, University of North Carolina, Greensboro, North Carolina
**Spielverderber** Forum Stadtpark Graz
**Ou les oiseaux selon Schopenhauer** Musée des Beaux-Arts d'Agen, Frankreich *France*
**Head and Shoulders** Brooke Alexander, New York

1993
**The Return of the Cadvre Exquis** The Drawing Center, New York
**Anniversary Exhibition, Part III** Daniel Weinberg Gallery, Santa Monica
**American Art in the Twentieth Century** Royal Academy of Arts, London
**Drawing the Line Against AIDS** AmFAR International, Sammlung Peggy Guggenheim an der 45. Biennale von Venedig *The Peggy Guggenheim Collection at the 45th Venice Biennial*
**Jeff Koons, Andy Warhol** Anthony d'Offay Gallery, London
**Amerikanische Kunst im 20. Jahrhunndert** Martin-Gropius-Bau, Berlin
**1982-83: Ten Years After** Tony Shafrazi Gallery, New York
**Jeff Koons, Roy Lichtenstein, Gerhard Merz, Albert Oehlen, Thomas Struth** Galerie Max Hetzler, Köln *Cologne*
**The Elusive Object** Whitney Museum of American Art at Champion, Stamford, Connecticut
**Zeitsprünge. Künstlerische Positionen der 80er Jahre** Wilhelm-Hack-Museum, Ludwigshafen
**Photoplay: Works from the Chase Manhattan Collection** Center for the Fine Arts, Miami; Museo Amparo, Puebla, Mexico; Museo de Arte Contemporáneo de Monterrey, Monterrey, Mexico; Centro Cultural Consolidado, Caracas, Venezuela; Museu de Arte Moderna de São Paulo, São Paulo, Brasilien *Brasil*; Museo Nacional de Bellas Artes, Santiago, Chile (Katalog *catalogue*, 1992)

1992
**Al(l)ready Made** Museum voor hedendaagse kunst, 's-Hertogenbosch, Niederlande *The Netherlands*
**Strange Developments** Anthony d'Offay Gallery, London
**Made For Arolsen** Schloß Arolsen, Bad Arolsen, Deutschland *Germany*
**Post Human** Musée d'Art Contemporain, Pully/Lausanne; The Israel Museum, Jerusalem; Deichtorhallen, Hamburg
**Group Show** Galerie Max Hetzler, Köln *Cologne*

**Selected Works From The Early Eighties** Kunstraum Daxer, München *Munich* (Katalog *catalogue*)
**Doubletake: Collective Memory & Current Art** Hayward Gallery, London

1991
**Quindicesima Biennale Internazionale del Bronzetto Piccola Scultura** Palazzo della Ragione, Padua *Padova*
**Group Show** American Fine Arts, Co., New York
**Objects for the Ideal Home: The Legacy of Pop Art** Serpentine Gallery, London
**Group Show** Andrea Rosen Gallery, New York
**Power: Its Myths, Icons, and Structures in American Culture, 1961-1991** Indianapolis Museum of Art, Indianapolis; Akron Art Museum, Akron, Ohio; Virginia Museum of Fine Arts, Richmond, Virginia
**Vertigo: 'The Remake'** Galerie Thaddaeus Ropac, Salzburg
**La Sculpture Contemporaine après 1970** Fondation Daniel Templon, Musée Temporaire, Frejus, Frankreich *France*
**Metropolis** Martin-Gropius-Bau, Berlin
**About Collecting: Four Collectors, Four Spaces** Ronny Van De Velde, Antwerpen *Antwerp*, Belgien *Belgium*
**Gulliver's Travels** Galerie Sophia Ungers, Köln *Cologne*
**Word as Image** Contemporary Arts Museum, Houston, Texas
**A Duke Student Collects: Contemporary Art from the Collection of Jason Rubell** Duke University Museum of Art, Durham, North Carolina (Katalog *catalogue*)
**Towards a New Museum. Recent Acquisitions in Painting and Sculpture, 1985-91** San Francisco Museum of Modern Art
**Who Framed Modern Art or the Quantitative Life of Roger Rabbit** Sidney Janis Gallery, New York
**Devil on the Stairs: Looking Back on the Eighties** Institute of Contemporary Art, University of Pennsylvania, Philadelphia; Newport Harbor Art Museum, Newport Beach, California (Katalog *catalogue*)
**Compassion and Protest: Recent Social and Political Art from the Eli Broad Family Foundation Collection** San Jose Museum of Art, San Jose, California (Katalog *catalogue*)

1990
**Culture and Commentary: An Eighties Perspective** Hirshhorn Museum and Sculpture Garden, The Smithsonian Institution, Washington, D.C.
**Art = Money?** The Gallery, New York
**Weitersehen (1980-1990)** Museum Haus Lange, Krefeld; Museum Haus Esters, Krefeld, Deutschland *Germany*
**Group Show** Galerie Max Hetzler, Köln *Cologne*

**The Charade of Mastery** Whitney Museum of American Art, Downtown at Federal Reserve Plaza, New York

**Vertigo** Galerie Thaddaeus Ropac, Paris

**Einladung** Galerie Carola Mosch, Berlin

**The Transformation of the Object** Grazer Kunstverein, Graz

**High & Low: Modern Art and Popular Culture** The Museum of Modern Art, New York; The Art Institue of Chicago; Museum of Contemporary Art, Los Angeles

**Images in Transition: Photographic Representation in the Eighties** The National Museum of Modern Art, Kyoto, Japan

**The Last Decade: American Artists of the '80s** Tony Shafrazi Gallery, New York

**Jardins de Bagatelle** Galerie Tanit, München *Munich*

**Life – Size: A Sense of the Real in Recent Art** The Israel Museum, Jerusalem

**Artificial Nature** The Dakis Joannou Collection Foundation, Athen *Athens*

**Aperto: Biennale di Venezia** Venedig *Venice*

**The 8th Biennale of Sydney** Sydney

**OBJECTives: The New Sculpture** Newport Harbor Art Museum, Newport Beach, California

**1990 – ENERGIES** Stedelijk Museum, Amsterdam

**New Work: A New Generation** San Francisco Art Museum

**The Indomitable Spirit** International Center of Photography at Midtown, New York; The Los Angeles Municipal Art Gallery, Los Angeles

**Horn of Plenty** Stedelijk Museum, Amsterdam

**Editionen von Jeff Koons** Galerie Gisela Capitain, Köln *Cologne*

**The Last Laugh** Massimo Audiello Gallery, New York

**Work as Image in American Art: 1960-1990** Milwakee Art Museum, Milwakee, Wisconsin

**Culture and Commentary** Hirshhorn Museum and Sculpture Garden, The Smithsonian Institution, Washington, D.C.

1989

**Image World** Whitney Museum of American Art, New York

**D&S Ausstellung** Kunstverein in Hamburg

**Mit dem Fernrohr durch die Kunstgeschichte** Kunsthalle Basel

**Psychological Abstraction** The Dakis Joannou Collection Foundation, Athen *Athens*

**The Silent Baroque** Galerie Thaddaeus Ropac, Salzburg

**A Forest of Signs: Art in the Crisis of Representation** Museum of Contemporary Art, Los Angeles

**1989 Whitney Biennial** Whitney Museum of American Art, New York

**Conspicuous Display** Stedman Art Gallery, Rutgers University, Camden, New Jersey

**Suburban Home Life: Tracking the American Dream** Whitney Museum of American Art Downtown at Federal Reserve Plaza, New York

1988

**Three Decades: The Oliver Hoffman Collection** The Museum of Contemporary Arts, Chicago
(Katalog *catalogue*)

**The Carnegie International** The Carnegie Museum of Art, Pittsburgh

**Hybrid Neutral: Modes of Abstraction and the Social** The University of North Texas Art Gallery,
Denton, Texas; The J.B. Speed Art Museum, Louisville, Kentucky; Alberta College Gallery of Art,
Calgary, Alberta, Canada; The Contemporary Arts Center, Cincinnati, Ohio; Richard F. Brush Art
Gallery, St. Lawrence University, Canton, New York; Santa Fe Community College Art Gallery,
Gainesville, Florida

**L'Objet de L'Exposition** Centre National des Arts Plastiques, Paris

**Collection Pour Une Region** CAPC Musée d'Art Contemporain, Bordeaux

**Artschwager: His Peers and Persuasion, 1963–1988** Daniel Weinberg Gallery, Los Angeles;
Leo Castelli Gallery, New York

**New York in View** Kunstverein München, München/Munich (Katalog *catalogue*)

**Sculpture Parallels** Sidney Janis Gallery, New York

**Schlaf der Vernunft** Museum Fridericianum, Kassel

**Cultural Geometry** The Dakis Joannou Collection Foundation, Athen *Athens*

**Redefining the Object** University Art Galleries, Wright State University, Dayton, Ohio

**New York Art Now – Part Two** Saatchi Collection, London (Katalog *catalogue*)

**Altered States** Kent Fine Art Gallery, New York

**A 'Drawing' Show** Cable Gallery, New York

**Art at the End of the Social** Rooseum Center for Contemporary Art, Malmö, Schweden *Sweden*

**New York, New York** Galleria 57, Madrid

**Nancy Spero: Works Since 1950 and Jeff Koons** Museum of Contemporary Art, Chicago

**Works – Concepts – Processes – Situations – Information** Ausstellungsraum Hans Mayer,
Düsseldorf

**New Works** Daniel Weinberg Gallery, Los Angeles

**The BiNational** Institute of Contemporary Arts, Boston; Kunsthalle Düsseldorf

1987

**Collection Sonnabend** Museo Nacional Centro de Arte Reina Sofia, Madrid; CAPC, Bordeaux

**NY Art Now** The Saatchi Collection, London

**New York New** Galerie Paul Maenz, Köln *Cologne*

**Post-Abstract Abstraction** The Aldrich Museum of Contemporary Art, Ridgefield, Connecticut

**Avant-Garde in the Eighties** Los Angeles County Museum, Los Angeles

**Les Courtiers du Desir** Galeries Contemporaines, Centre Pompidou, Paris

**1987 Whitney Biennial** Whitney Museum of American Art, New York (Katalog *catalogue*)

**This is Not a Photograph: 20 Years of Large Scale Photography** The John and Marble Ringling

Museum of Art, Saratosa, Florida; Akron Art Museum, Akron, Ohio; The Chrysler Museum of Art, Norfolk, Virginia
**True Pictures**  John Good Gallery, New York
**Romance**  Knight Gallery, Charlotte, North Carolina
**Art & It's Double: A New York Perspective**  Fundació Caixo de Pensions, Barcelona (Katalog *catalogue*)
**Skulptur Projekte Münster 1987**  Westfälisches Landesmuseum für Kunst- und Kulturgeschichte, Münster (Katalog *catalogue*)

1986
**Group Show**  Galerie Max Hetzler, Köln *Cologne*
**Endgame: Reference and Simulation in Recent Painting and Sculpture**  Institute of Contemporary Art, Boston
**Prospect 86**  Schirn Kunsthalle, Frankfurt a.M.
**A Brokerage of Desire**  Otis Parsons Exhibition Center, Los Angeles
**The Drawing Show**  Pat Hearn Gallery, New York
**Modern Objects, A New Dawn**  Baskerville & Watson, New York
**New Sculpture**  Renaissance Society, University of Chicago
**Spirtual America**  CEPA Galleries, Buffalo, New York
**Time After Time**  Diane Brown, New York
**Objects from the Modern World**  Daniel Weinberg Gallery, Los Angeles
**Group Show**  Jay Gorney Modern Art, New York
**Admired Work**  John Weber Gallery, New York
**Damaged Goods**  The New Museum of Contemporary Art, New York; Otis Parsons Exhibition Center, Los Angeles
**Paravision**  Margo Leavin Gallery, Los Angeles; Donald Young Gallery, Chicago
**Group Show**  Sonnabend Gallery, New York

1985
**Cult and Decorum**  Tibor de Nagy Gallery, New York,
**Post Production**  Feature, Chicago
**Group Show**  303 Gallery, New York
**New Ground**  Luhring, Augustine & Hodes Gallery, New York
**Affiliations: Recent Sculpture and its Antecedents**  Whitney Museum of American Art at Champion, Stamford, Connecticut
**Group Show**  International With Monument Gallery, New York
**Logosimuli**  Daniel Newburg Gallery, New York
**Paravision**  Postmasters, New York

**Objects in Collision**  The Kitchen, New York
**Signs II**  Michael Klein Inc., New York
Galerie Crousel-Hussenot, Paris

1984
**The New Capital**  White Columns, New York
**Objectivity**  Hallwalls, Buffalo, New York
**Light Moving**  Kamikaze, New York
**A Decade of New Art**  Artist's Space, New York
**Pop**  Spirtual America, New York
**New Sculpture**  School 33, Baltimore, Maryland

1983
**Science Fiction**  John Weber Gallery, New York
**Los Angeles – New York Exchange**  Artist's Space, New York; LACE, Los Angeles
**Objects, Structures, Artifices**  University of South Florida, Tampa; Bucknell University,
Lewisburg, Pennsylvania
**Hundreds of Drawings**  Artist's Space, New York

1982
**A Fatal Attraction: Art and the Media**  Renaissance Society, University of Chicago
**A Likely Story**  Artist's Space, New York
**Energie New York**  Espace Lyonnais d'Art Contemporain, Lyon

1981
**Lighting**  P.S.1, Long Island City, New York
Annina Nosei Gallery, New York
**Moonlighting**  Joseph Gallery, New York
Maryland Institute College of Art, Baltimore
Barbara Gladstone Gallery, New York

1980
**Art for the Eighties**  Galeria Durban, Caracas, Venezuela

## AUSGEWÄHLTE PUBLIKATIONEN *SELECTED PUBLICATIONS*
### in umgekehrt chronologischer Reihenfolge *in reverse chronological order*

### Kataloge, Monographien, Sammelwerke *Catalogues, Monographs, Compilations*

**Au-Delà du Spectacle**, Ausst.kat. Centre Pompidou, Paris, 2001

**Jeff Koons: Easyfun – Ethereal**, Ausst.kat. Deutsche Guggenheim, Berlin, 2000

**Hypermental. Wahnhafte Wirklichkeit 1950-2000. Von Salvador Dali bis Jeff Koons**, Ausst.kat. Kunsthaus Zürich, 2000

**Apocalypse: Beauty & Horror in Contemporary Art**, Ausst.kat. Royal Academy of Arts, London, 2000

**Ausblick auf das neue Jahrtausend / Art at The Turn of the Millennium**, hg. von Burkhard Riemschneider, Uta Grosenick, Köln 1999

**Rosenblum, Robert: On Modern American Art. Selected Essays**, New York, 1999

**Tuning up #5**, Ausst.kat. Kunstmuseum Wolfsburg, 1998

**L'Envers du Décor. Dimensions décoratives dans l'art du XXe siècle**, Ausst.kat. Musée d'art moderne, Lille; Métropole, Villeneuve d'Ascq, 1998

**Interno – Esterno/Alterno**, Ausst.kat. FENDI, New York, 1998

**Jeff Koons**, Ausst.kat. Galerie Jérôme de Noirmont, Paris, 1997

**Dramatically Different**, hg. von Yves Aupetitallot, Ausst.kat. Magasin - Centre National d'Art Contemporain de Grenoble, Grenoble, 1997

**On the Edge: Contemporary Art from the Werner and Elaine Dannheisser Collection**, Ausst.kat. The Museum of Modern Art, New York, 1997)

**4e biennale d'art contemporain de Lyon: 'L'Autre'**, Ausst.kat., Lyon, 1997

**Objects of Desire: The Modern Still Life**, Ausst.kat. The Museum of Modern Art, New York, 1997

**Zaunschirm, Thomas: Kunst als Sündenfall. Die Tabuverletzungen des Jeff Koons**, Freiburg i.Br., 1996

**Art at Home – Ideal Standard Life**, Spiral Garden, Ausst.kat., Tokyo 1996

**Collective vision: Creating a Contemporary Art Museum**, Ausst.kat. Museum of Contemporary Art, Chicago, 1996

**Everything That's Interesting is New: The Dakis Joannou Collection**, hg. von Jeffrey Deitch und Louise Neri, Ostfildern-Ruit, 1996

**Zeichen & Wunder. Niko Pirosmani (1862-1918) und die Kunst der Gegenwart**, hg. von Bice Curiger, Ausst.kat. Kunsthaus Zürich, 1995

**Going for Baroque**, Ausst.kat. The Contemporary and the Walters Art Gallery, Baltimore, 1995

**Kaldor, John und Nicholas Baume: From Christo and Jeanne-Claude to Jeff Koons. John Kaldor Art Projects and Collection**, Ausst.kat. Museum of Contemporary Art, Sydney, 1995

**Koons, Jeff: The Jeff Koons Daybook**, New York, 1994

**Photoplay: Works from the Chase Manhattan Collection**, Ausst.kat. Center for the Fine Arts, Miami, 1992

**Selected Works From The Early Eighties**, Ausst.kat. Kunstraum Daxer, München, 1992

**Jeff Koons**, Ausst.kat. San Francisco Museum of Modern Art, 1992

Collings, Matthew: „Jeff Koons", in: **Pop Art**, Ausst.kat. Royal Academy of Art, London, 1992

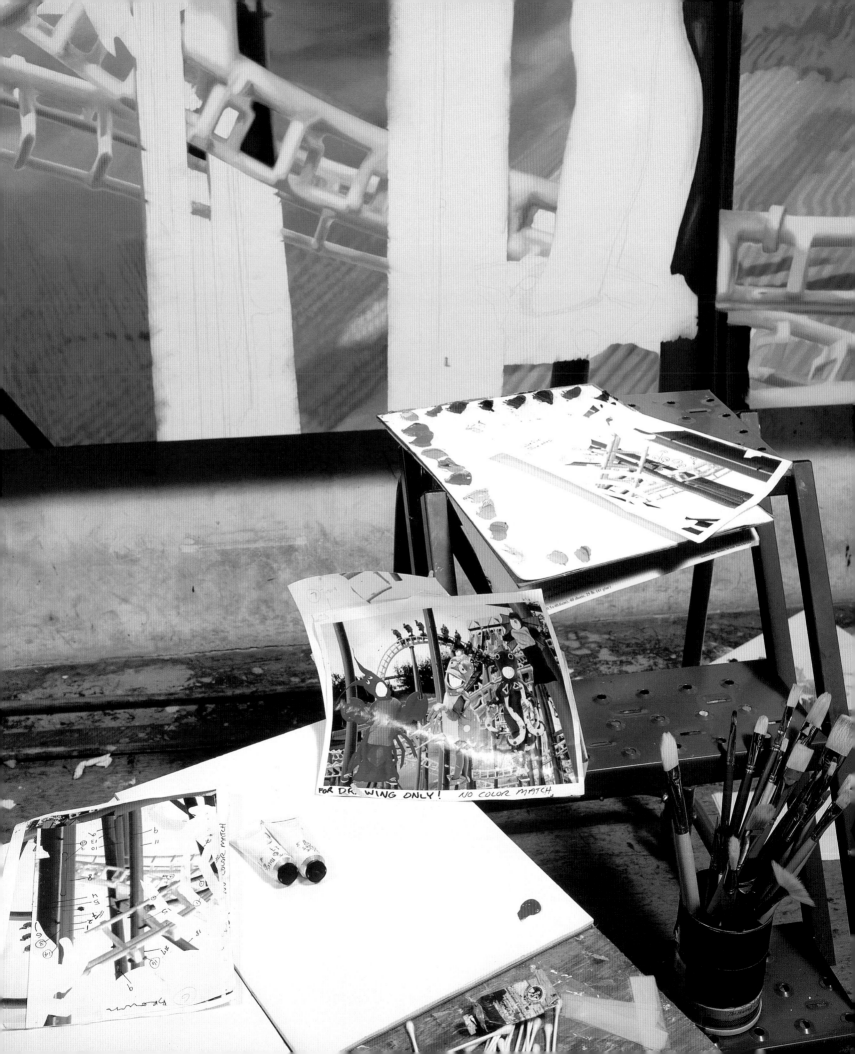

FOR DR. WING ONLY! NO COLOR MATCH

**Koons, Jeff und Robert Rosenblum: The Jeff Koons Handbook**, London, Anthony d'Offay Gallery, 1992 / deutsch: **Das Jeff Koons Handbuch**, München, 1992

**Jeff Koons**, hg. von Angelika Muthesius, Interview von Anthony Haden-Guest, Text von Jean-Christophe Ammann, Köln, 1992 / english: **Jeff Koons**, New York, 1997

Livingstone, Marco: „The Legacy of Pop Art", in: **Objects for the Ideal Home**, Ausst.kat. Serpentine Gallery, London, 1991

**Metropolis**, Ausst.kat. Martin-Gropius-Bau, Berlin, 1991

**A Duke Student Collects: Contemporary Art from the Collection of Jason Rubell**, Ausst.kat. Duke University Museum of Art, Durham, North Carolina, 1991

**Devil on the Stairs: Looking Back on the Eighties**, hg. von Robert Storr, Ausst.kat. Institute of Contemporary Art, University of Pennsylvania Press, Philadelphia, 1991

Varnedoe, Kirk und Adam Gopnik:„Contemporary Reflections", in: **High and Low**, Ausst.kat. Museum of Modern Art, New York, 1990

**Koons, Jeff: Jeff Koons**, Pharmakon 90, Tokyo, 1990

Block, René: „The Readymade Boomerang", in: **Art is Easy**, Ausst.kat. Sydney Biennial, Sidney, 1990

**Jeff Koons**, Whitney Biennial, Ausst.kat. Whitney Museum of American Art, New York, 1989

**Schlaf der Vernunft**, hg. von Veit Loers, Ausst.kat. Museum Fridericianum, Kassel, 1988

**Three Decades: The Oliver Hoffman Collection**, Ausst.kat. The Museum of Contemporary Arts, Chicago, 1988

**Jeff Koons**, hg. von Michael Danoff, Ausst.kat. Museum of Contemporary Art, Chicago, 1988

**New York in View**, Ausst.kat. Kunstverein München, München, 1988

**New York Art Now - Part Two**, Ausst.kat. Saatchi Collection, London, 1988

Celant, Germano: „The Mable Period", in: **Unexpressionism. Art beyond the Contemporary**, New York, 1988

**Tomkins, Calvin: Post - to Neo. The Art World of the Eighties**, New York, 1988

**Post-Abstract Abstraction**, Ausst.kat. Aldrich Museum of Contemporary Art, Ridgefield, 1987

**1987 Whitney Biennial**, Ausst.kat. Whitney Museum of American Art, New York, 1987

**Skulptur Projekte Münster 1987**, hg. von Georg Joppe, Ausst.kat. Westfälisches Landesmuseum für Kunst- und Kulturgeschichte, Münster, Landschaftsverb. Westfalen Lippe, 1987

**Art & Its Double**, Ausst.kat. Fondació Caixa de Pensiones, Barcelona, 1986

**Endgame. Reference and simulation in recent painting and sculpture**, Ausst.kat. Institute of Contemporary Art, Boston, 1986

## AUSGEWÄHLTE PUBLIKATIONEN *SELECTED PUBLICATIONS*
### in umgekehrt chronologischer Reihenfolge *in reverse chronological order*

### Periodika *Periodicals*

Bell, Bowyer: „A Good Deed undone. Jeff Koons at Sonnabend Gallery", **Review New York**, 1999, http://www.reviewny.com/current/99_00/dec_1/artfeatures1.html, Juni 2001

Beech, Dave und John Beagles: „All You Need Is Love", **Art Monthly**, Nr. 233, Februar 2000

Muniz, Vik: „Eternal regress / Fortwährende Rückkehr", **Parkett**, Nr. 50/51, 1997

Seward, Keith: „Frankenstein in Paradise / Frankenstein im Paradies", **Parkett**, Nr. 50/51, 1997

Loers, Veit: „Puppy, das Herz Jesu / Puppy, the Sacred Heart of Jesus", **Parkett**, Nr. 50/51, 1997

Rimanelli, David: „It's My Party: Jeff Koons, A Studio Visit", **Artforum International**, Bd. 35, Nr. 10, Sommer 1997

Ratcliff, Carter: „Not for Repro", **Artforum International**, Bd. 30, Nr. 6, Februar 1992

Avgikos, Jan: „All That Heaven Allows: Love, Honor and Koonst", **Flash Art**, Nr. 171, Sommer 1993

Rosenblum, Robert: „Jeff Koons: Christ and the Lamb", **Artforum International**, Bd. 32, Nr. 1, September 1993

Lewis, Jim: „Beyond Redemption", **Artforum International**, Bd. 29, Nr. 10, Sommer 1991

Deitch, Jeffrey: „L'industria dell'Arte", **Flash Art**, June 1991

Storr, Robert: „Gym-Dandy: An Interview with Jeff Koons", **Art Press**, Nr. 151, Oktober 1990

Morgan, Stuart, et al.: „Big Fun: Four Reactions to Jeff Koons", **Artscribe**, Nr. 74, März-April 1990

Koons, Jeff, Martin Kippenberger: „Collaborations", in: **Parkett**, Nr. 19, 1989

Ammann, Jean-Christophe: „Der Fall Jeff Koons / Jeff Koons: Case Study", in: **Parkett**, Nr. 19, 1989

Diederichsen, Diedrich: „I'll Buy That", in: **Parkett**, Nr. 19, 1989

Schwartzman, Allan: „The Yippie-Yuppie Artist", **Manhattan, Inc.** 4, Nr. 12, Dezember 1987

Politi, Giancarlo: „Luxury and Desire: An Interview with Jeff Koons", **Flash Art**, Nr. 132, Februar-März 1987

Cameron, Dan: „Pretty as a Product", **Arts Magazine**, Nr. 60, Mai 1986

# BILDNACHWEIS *PHOTO CREDIT*

**Auto** (S. 96/97): Foto *photo*: Tom Powel, New York; Courtesy of Gagosian Gallery, New York

**Balloon Dog** (S. 36/37): Foto *photo*: Jim Strong

**Beach** (S. 103): Foto *photo*: Tom Powel, New York

**Bear (Dark Green)** (S. 57), **Cow (Lilac)** (S. 65), **Donkey** (S. 63), **Donkey (Orange)** (S. 76), **Elephant (Dark Blue)** (S. 71), **Giraffe (Light Brown)** (S. 59), **Goat ( Dark Pink)** (S. 68), **Hair** (S. 64), **Hippo (Dark Pink)** (S. 60), **Kangaroo (Orange)** (S. 72), **Loopy** (S. 69), **Saint Benedict** (S. 75), **Sheep (Yellow)** (S. 73), **Walrus (Red)** (S. 67): alle Fotos *all photos*: Lawrence Beck; Courtesy Sonnabend Gallery, New York

**Bracelet** (S. 32/33): Foto *photo*: Ali Elai-Camerarts Studio, New York; Courtesy Anthony d'Offay Gallery, London

**Bread with Egg** (S. 31): Foto *photo*: Prudence Cuming & Associates, London; Courtesy Anthony d'Offay Gallery, London

**Candle** (S. 104/105): Foto *photo*: Tom Powel, New York; Courtesy Gagosian Gallery, New York

**Cheeky** (S. 95): Foto *photo*: Tom Powel, New York

**Couple** (S. 100/101): Foto *photo*: Douglas M. Parker Studio, Los Angeles

**Cut-Out** (S. 58): Foto *photo*: Lawrence Beck, New York

**Desert** (S. 47), **Elephants** (S. 50), **Pancakes** (S. 84), **Stream** (S. 87): alle Fotos *all photos*: Douglas M. Parker Studio, Los Angeles; Courtesy Gagosian Gallery, Los Angeles

**Hanging Heart** (S. 27): Foto *photo*: Ali Elai-Camerarts Studio, New York; Courtesy The Dakis Joannou Collection Foundation, Athen *Athens*

**Inflatable Flower and Bunny** (S. 12): Foto *photo*: Douglas M. Parker Studio, Los Angeles

**Pam** (S. 99): Foto *photo*: Douglas M. Parker Studio, Los Angeles; Courtesy Gagosian Gallery, Los Angeles

**Pink Bow** (S. 27/28): Foto *photo*: Jim Strong, New York

**Plate Set** (S. 35): Foto *photo*: Ali Elai-Camerarts Studio, New York

**Play-Doh** (S. 44): Foto *photo*: Ellen Labenski

**Ribbon** (S. 80): Foto *photo*: Courtesy Galerie Max Hetzler, Berlin

**Tulips** (S. 41): Foto *photo*: Tom Powel, New York

Raumansicht der Ausstellung **Easyfun,** Sonnabend Gallery, New York 1999 *Exhibition **Easyfun**, installation view, Sonnabend Gallery, New York 1999* (S. 11, 83): Foto *photo:* Lawrence Beck; Courtesy Sonnabend Gallery, New York

Raumansicht der Ausstellung **Jeff Koons: A Survey 1981-1994,** Anthony d'Offay Gallery, London 1994 *Exhibition **Jeff Koons: A Survey 1981-1994**, installation view, Anthony d'Offay Gallery, London 1994* (S. 16): Foto *photo*: Marcus Leith; Courtesy Anthony d'Offay Gallery, London

Raumansicht der Ausstellung **Jeff Koons: New Paintings,** Gagosian Gallery, Los Angeles 2001 *Exhibition **Jeff Koons: New Paintings**, installation view, Gagosian Gallery, Los Angeles 2001* (S. 20): Foto *photo*: Douglas M. Parker Studio, Los Angeles; Courtesy Gagosian Gallery, Los Angeles

Raumansicht der Ausstellung **Banality,** Galerie Max Hetzler, Köln 1988 *Exhibition **Banality**, installation view, Galerie Max Hetzler, Cologne 1988* (S. 19): Foto *photo*: Courtesy Galerie Max Hetzler, Berlin

**Atelierfotos Jeff Koons** *studio photographs Jeff Koons* (S. 119, 129, 135): David Heald; Courtesy The Solomon R. Guggenheim Museum, New York

Foto *photo* **Jeff Koons** (S. 2): Oliver Mark, Berlin

## IMPRESSUM *COLOPHONE*

Der Katalog erscheint anlässlich der Ausstellung
*This catalogue is published on the occasion of the exhibition*

**Jeff Koons**

18. Juli bis 16. September 2001
*18 July to 16 September 2001*

**Kunsthaus Bregenz**
Karl Tizian Platz, A-6900 Bregenz
Tel (+43-5574) 485 94-0
Fax (+43-5574) 485 94-8
kub@kunsthaus-bregenz.at
www.kunsthaus-bregenz.at

Direktor *Director*: Eckhard Schneider
Kurator *Curator*: Rudolf Sagmeister
Kommunikation *Press and Public Relations*: Eva Thole
Kunstvermittlung *Art Education*: Winfried Nußbaummüller
Publikationen und Archiv *Publications and Archive*:
Herbert Abrell
Technik *Technical Staff*: Markus Unterkircher (Leiter *Head*),
Markus Tembl, Stefan Vonier
Administration *Administration*: Ute Denkenberger
Sekretariat *Office*: Cornelia Marlovits, Margit Müller-Schwab

**Ausstellung *Exhibition***

Eckhard Schneider
Projektassistenz *Assistant*: Herbert Abrell, Cornelia Marlovits
Technik und Aufbau *Technics and set-up*: Markus Unter-
kircher (Leiter *Head*), Markus Tembl, Stefan Vonier

Versicherung *Insurance*: AXA Nordstern Versicherungs-AG,
Wien *Vienna*
Transporte *Shipping*: Hasenkamp Internationale Transporte,
Köln-Frechen; Masterpiece, New York; Ermanno de Marinis,
Neapel *Naples*; Nassos Bergeles, Athen *Athens*

Mit freundlicher Unterstützung von *Sponsored by*
AXA Nordstern Versicherungs-AG, Wien *Vienna*
Hypo Landesbank, Bregenz

**Katalog *Catalogue***

Herausgeber *Editor*: Eckhard Schneider, Kunsthaus Bregenz
Redaktion *Editorial work*: Herbert Abrell
Gestaltung *Graphic design*: Martina Goldner, Büro für Kunst
Übersetzungen *Translations*: Bettina Blumenberg, Kimi Lum
Herstellung, Lithographie und Druck *Production,
Reproduction works and printing*: Höfle Druck, Dornbirn

Verlag der Buchhandlung Walther König
Ehrenstrasse 4, D-50672 Köln
Tel (+49-221) 205 96-53
Fax (+49-221) 205 96-60

Die Deutsche Bibliothek - CIP-Einheitsaufnahme
*CIP Cataloguing-in-Publication-Data*

Ein Titelsatz für diese Publikation ist bei der Deutschen
Bibliothek erhältlich
*A catalogue record for this publication is available from
Die Deutsche Bibliothek*

ISBN 3-88375-515-X

Auflage *Number of copies*:
7000 im Juli 2001 *in July 2001*

Unser besonderer Dank gilt *Special thanks to*
Anthony d'Offay Gallery, London
Gagosian Gallery, New York
Galerie Max Hetzler, Berlin
No Limits Gallery, Neapel *Naples*, Mailand *Milan*
Sonnabend Gallery, New York

# INHALT *CONTENT*

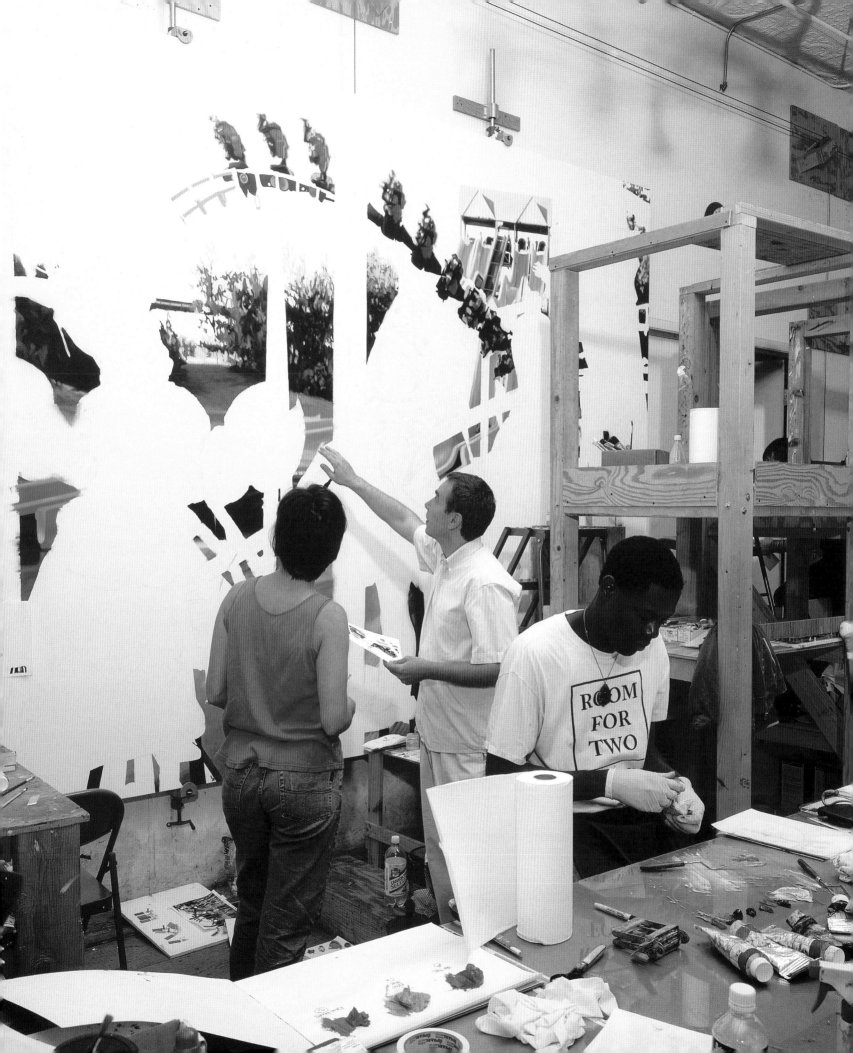